IMAGES
of America

GREAT NECK

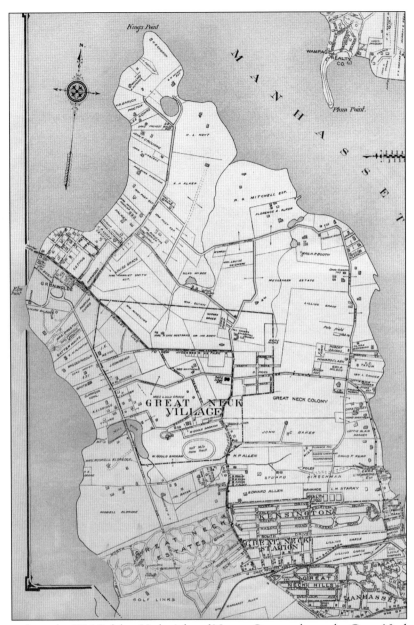

This map, from the 1914 Belcher Hyde *Atlas of Nassau County*, shows the Great Neck peninsula and the names of some prominent landowners. Great Neck was already beginning to be carved into its present villages, and the roads of Great Neck Estates, Kensington, and Thomaston (labeled Manhasset on the map) are clearly visible. The southern areas, including Lake Success, are not shown on the map. (Courtesy of Alice Kasten.)

ON THE COVER: Great Neck is indebted to its three hardworking volunteer fire departments. This photograph shows the members of the racing team of the Alert Volunteer Fire Department, taken right after its August 18, 1902, victories at the New York State Firemen's Tournament. The uniformed gentleman is Henry Ninesling, the owner of the first department store in Great Neck. (Courtesy of the Great Neck Library.)

IMAGES
of America

GREAT NECK

Judy — We go back in Great Neck history!

Alice Kasten and Leila Mattson

Alice Kasten

Leila Mattson

ARCADIA
PUBLISHING

Published by Arcadia Publishing
Charleston, South Carolina

Printed in the United States of America

Library of Congress Control Number: 2012955975

For all general information, please contact Arcadia Publishing:
Telephone 843-853-2070
Fax 843-853-0044
E-mail sales@arcadiapublishing.com
For customer service and orders:
Toll-Free 1-888-313-2665

Visit us on the Internet at www.arcadiapublishing.com

CONTENTS

ACKNOWLEDGMENTS

Our deepest gratitude goes to the Great Neck Library for permitting access to the extensive resources of the Great Neck History Collection. We specifically acknowledge the efforts of the late librarian Risha Rosner, who had a strong interest in the history of Great Neck and added much to the collection. Unless otherwise noted, the images in this volume come from the files of the Great Neck Library; we are indebted to the library for the permission to use them.

This book would not have been possible without the interest and skills of librarian Jonathan Aubrey, who helped immeasurably by preparing the images for publication. Jonathan has a deep curiosity about Great Neck's past and enjoys sharing his knowledge with the community.

In addition to the publications listed in the bibliography, we have consulted newspapers, including the *New York Times*, *Newsday*, the *Great Neck Record*, and the *Great Neck News*, as well as local telephone directories, Robinson's community directories, many websites, and also numerous reference books in the library's extensive collection. The Great Neck Library's website was invaluable, both for its photograph collection and its archives of scanned documents.

Specific acknowledgments go to Jack Binder, Howard Bauman, Mort Hans, Helene Herzig, Howard Kroplick, and Charles Quatela for sharing photographs. We also thank everyone who has contributed photographs, documents, and reminiscences to the Great Neck Library; this book could not have been created without them.

INTRODUCTION

Great Neck has grown and flourished on a peninsula jutting out into Long Island Sound, within easy access by water to New York City. The original settlers found fertile land—dropped here by the last glacial retreat—and established mills and farms, selling their crops in the markets of New York. Many were staunch Quakers, believing in the value of education for all, and they were hard workers, establishing a community out of the forested lands.

In the 1800s, city residents traveled here by steamship to spend the day in the country. Excursion companies built recreational destinations, the most famous being Oriental Grove. Some picnickers later chose to make the move to the peninsula. By the mid-1800s, Great Neck saw the arrival of successful businessmen, who built magnificent summer homes and commuted to the city by steamboat. Most of the peninsula, however, was still carved into large farms, and the farming families bore names familiar to residents today, including Allen, Baker, and Schenck. A small business community developed in the north, along the main road between Arrandale Avenue and Beach Road, to serve both the farmers and the large estates.

From 1861 to 1865, a Civil War regiment, the Jackson Guards, trained at Camp Tammany near Elm Point, and 148 tents dotted the green hillsides. The officers frequented the Great Neck Hotel for refreshments.

The railroad arrived in 1866, making it easier for businessmen to commute to city offices. Commuting became even easier in 1910, when a tunnel was constructed under the East River, enabling the railroad to reach Manhattan. Automobiles appeared on local streets soon after, and highways and bridges were constructed.

Developers, recognizing the potential of Great Neck's farmlands, began buying land for what they promoted as high-class communities, with elegant homes, golf courses, country clubs, and pools. Residents began to voice concerns about controlling the growth of these communities. The McKnight Realty development was incorporated as Great Neck Estates in 1911, and other villages followed suit; by 1931, there were nine incorporated villages. Some areas remain unincorporated, and these areas, along with the villages, make up what we know as Great Neck today.

The easy commute changed the geography of business in Great Neck. Stores and services were established in what is now Great Neck Plaza. A new railroad station was built in 1925. The station was called Thomaston and was named by W.R. Grace, the former mayor of New York City. A dramatic change took place in 1937 when the tracks were lowered, removing the level-grade crossing.

Great Neck was also attractive to writers, actors, composers, and producers who needed to live within commuting distance of Broadway. The movie crowd also arrived. And those who did not live here partied here. Many celebrities did live here, however, including George M. Cohan, Oscar Hammerstein II, Eddie Cantor, Ed Wynn, Guy Bolton, Groucho Marx, P.G. Wodehouse, F. Scott Fitzgerald, Ring Lardner, Thomas Meighan, and Lillian Russell.

World War II left a lasting impression on Great Neck. The United States Merchant Marine Academy was established in 1942. The federal government built the Sperry Gyroscope plant in the village of Lake Success. After the war, part of the Sperry property became the home of the United Nations Security Council. New apartment buildings were constructed for the returning veterans and for employees of the United Nations.

The photographs in this volume largely end with World War II. However, that era was not the end of change in Great Neck. After the war, more modest homes began filling the remaining open land. For example, Louise Udall Eldridge's property was subdivided into 340 separate lots, ranch houses were built on the former Baker farm, and most of the remaining grand estates were developed. A corner of Squire Allen's farm, along South Middle Neck Road, became a shopping center.

The postwar years also brought a change in the ethnic balance of the community. Before the war, many immigrants came from European countries such as Ireland, Germany, Poland, and Lithuania to work on the estates. After the war, a large Jewish immigration occurred, with many families moving out of New York City and others coming from Europe. In the late 1970s, due to the pressures of the Islamic Revolution, many Iranians immigrated to Great Neck. Recent immigration has also brought many Asians and Israelis to the peninsula.

From a small English and Dutch farming community, Great Neck has evolved into a thriving international suburb that still retains its small-town atmosphere.

One

Mills and Farms

The Saddle Rock Grist Mill is one of the few remaining operative tidal gristmills in the country, due in large part to the fine craftsmanship of its builders. In 1940, the mill's owner, Louise Udall Eldridge, had it restored to operating condition.

The mill has had many owners. In 1702, Robert Hubbs sold Henry Allen his half-ownership of the mill, which Hubbs and his brother had operated for more than 20 years. In 1786, Henry Allen's son John took over operation of the mill. John's son later sold it to John Tredwell, and Richard Udall purchased the mill in 1833.

The Udalls used the mill as a terminal for active trade with nearby New York City. Sloops carried hay, chicken, eggs, and apples, and returned with household goods for the residents on the peninsula and manure from the streets of New York City for farms. Louise Udall Eldridge's will transferred the mill to the Nassau County Historical Society, which in turn deeded it to Nassau County.

Another mill, the lesser-known Allen mill, farther south on the peninsula, became known as the Cutter Mill after poet Bloodgood Cutter married Emeline Allen in 1840. A third mill, on what is now known as Whitney Pond, was owned by Alfred Doncourt.

For almost 200 years, the gristmills ground grain grown on the fertile farms of the peninsula. By the 1870s, the stone mills in the area became obsolete, and the farms on the peninsula gave way to great estates and later to the housing developments of the early 1900s.

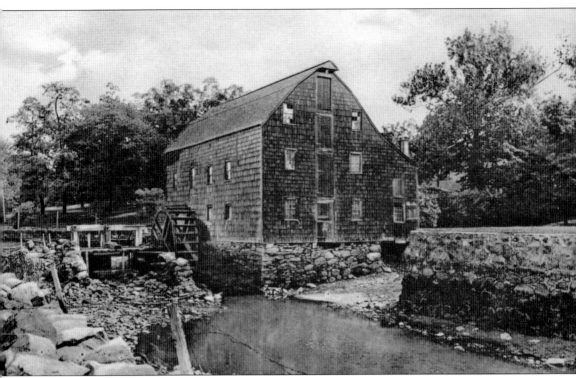

The Allen family operated the Saddle Rock Grist Mill for three generations. The millers ground oats, corn, barley, graham, buckwheat, rye, and other grains, which were grown on local farms. In the 1700s, there were more than 300 mills on the north shore, as mills were the principal industry on Long Island. The Saddle Rock mill was also a hub for the transportation of flour and produce from farms on the peninsula to New York City via the Long Island Sound. Sloops returned from New York City with goods for the growing number of households on the peninsula. (Courtesy of Alice Kasten.)

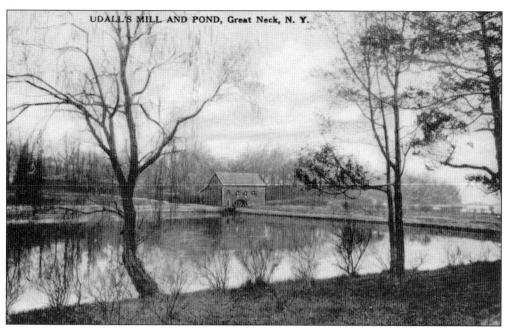

The Saddle Rock Grist Mill is a tidal mill. As the tide went out, a sluice gate was raised to release water from the millpond into Long Island Sound, directing the force of the water through the millrace to the wheel, which drove the millstones. Little Neck Bay is visible on the right.

In the 1800s, Margaretta Allen, the daughter of Jakamiah Allen and Mary Hewlett, owned this extensive farm on the north side of what is now Cedar Drive in Great Neck Estates. The property extended to Little Neck Bay. Margaretta also sometimes lived with her brother John at his home on the north side of the millpond. Members of the extended Allen family lived in many areas of Great Neck.

11

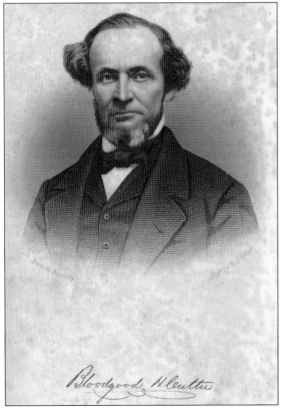

Bloodgood Haviland Cutter, known as "the farmer poet," inherited farms and waterfront acreage from his grandfather. He later acquired a mill from the family of his wife, Emeline Allen. Cutter wrote, in his typical style, "That is I mean the flour to grind/The very best, pure and refined." The photograph above is from a glass-plate negative created by Hal Fullerton. (Courtesy of the Suffolk County Historical Society.)

"How sad I feel as I sit still/On the loss of my ancient mill/On Saturday morn, 'bout 3 o'clock/The news gave me a dreadful shock." Bloodgood Cutter wrote poems about almost every occasion, including the loss of his mill when it burned. This portrait appears at the front of a book of his collected poems, *The Long Island Farmer's Poems*, published in 1886.

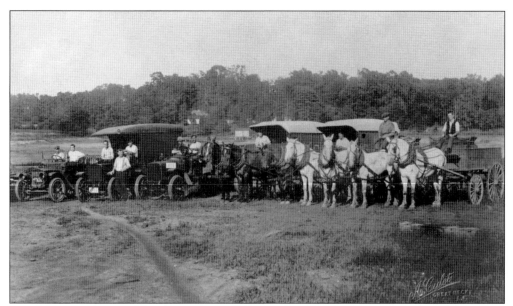

Great Neck farmers, with both motor vehicles and horse-drawn wagons, pose for Great Neck photographer Alexander Culet. A professional photographer, Culet recorded many scenes in the area, including businesses on Middle Neck Road and the grand estates. His photographs were frequently used to produce postcards like this one.

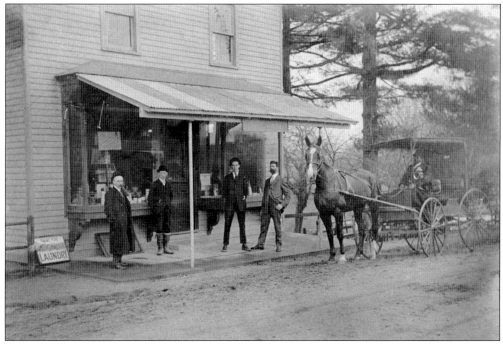

Four Doncourt brothers pose in front of their furnishings store on Northern Boulevard. Their father, Alfred, operated a gristmill on nearby Whitney Pond. The daughters of Augustus Doncourt remembered carts laden with produce on the boulevard, on their way to the city. Extra horses were needed on the steep hill. Augustus made many trips to the steamboat landing in Kings Point to pick up provisions for the store.

13

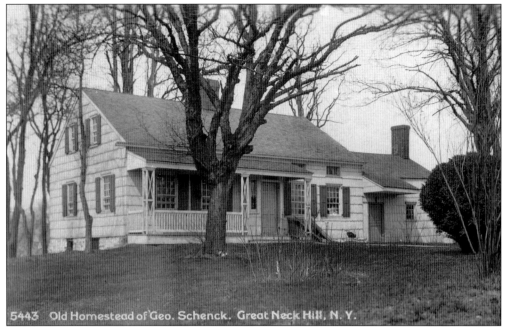

5443 Old Homestead of Geo. Schenck. Great Neck Hill, N. Y.

George Schenck's name appears in the Town of North Hempstead records from 1879, when he was appointed as commissioner of highways. Farmland owned by George and Henry Schenck occupied the area between what are now Schenck and Susquehanna Avenues. Schenck's house was purchased in 1909 by a developer, the Great Neck Improvement Company, and it was later moved to make way for the Great Neck Hills development.

Taken on Manhasset Avenue, near the highest spot on the peninsula, this photograph shows open farmland owned by the Great Neck Improvement Company, which was planning the Great Neck Hills development about 1910. Manhasset Avenue was soon renamed Schenck Avenue, and, within a few years, many houses were built on the former farm.

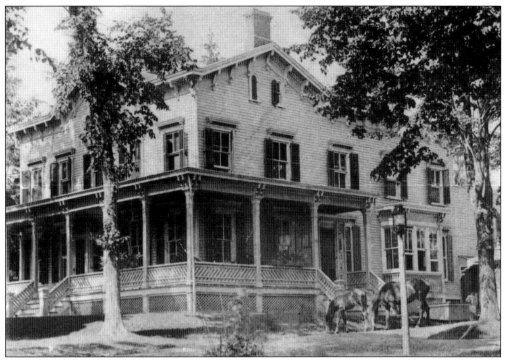

In 1855, Mills P. Baker moved to a farm that extended from Middle Neck Road to Station Road. Baker built this house in 1861 on a high spot, which is now the site of Baker Hill School. His grandson, also named Mills P. Baker, wrote that on clear days one could see the top of the Woolworth Building in Manhattan. (Baker family photograph, courtesy of Great Neck Library.)

In 1926, John Baker sold all but 15 acres of his 95-acre farm. The 1861 house was razed. The family returned to the original farmhouse, which was moved north of Baker Hill Road and remodeled. It is now the Great Neck Village Hall. In the 1930s, the Baker family estimated the farmhouse to be over 200 years old. (Baker family photograph, courtesy of Great Neck Library.)

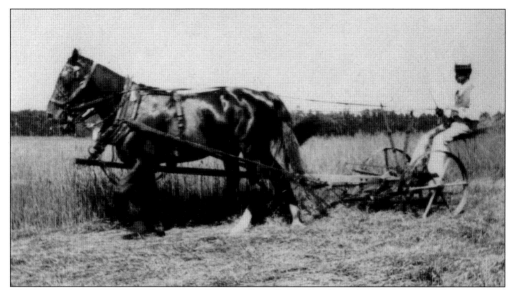

Hay, an important crop on the peninsula, was often shipped to feed the many horses that provided transportation for New York City. John Conger Baker is shown mowing hay in this late-19th-century photograph. There were nine fields on the farm—seven of these were in hay and the other two in corn and potatoes. (Baker family photograph, courtesy of Great Neck Library.)

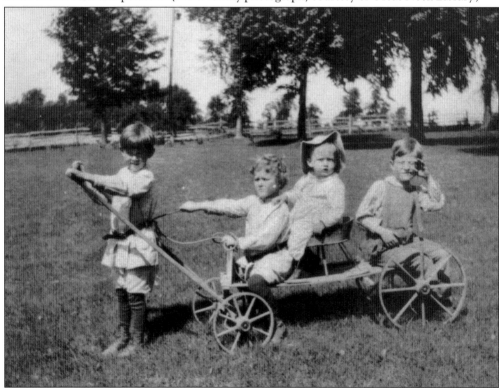

The Baker children enjoy life on the family farm in 1905. The boys are, from left to right, John Conger Baker Jr., J. Mellick Baker, Mills P. Baker—who later wrote a book about life on the farm—and Alan Wilcox, a cousin. (Baker family photograph, courtesy of Great Neck Library.)

John Conger Baker, the president and director of several banks in the area, was the chairman of the board of education and a school commissioner for North Hempstead. Elizabeth Mellick Baker was a member of the Woman's Club; the library's board of trustees, from 1924 to 1945; and the board of education, from 1918 to 1936. (Baker family photograph, courtesy of Great Neck Library.)

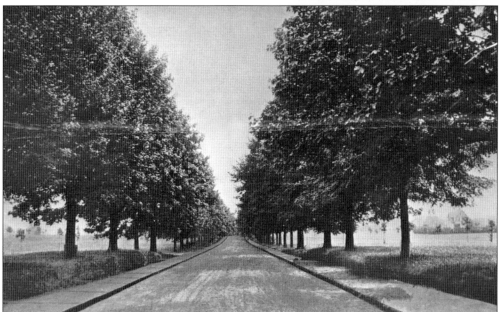

In 1909, Charles Finlay and E.J. Rickert spent more than $120,000 converting the 120-acre Deering property, formerly part of the Allen farm, into what they called a high-class residential park. The tree-lined Deering Lane, seen here, which bordered an apple orchard, became Beverly Road in the village of Kensington. The developers built large mansions for themselves near the entrance gates, adjacent to Beverly Road.

Members of the Woolley family were among the first settlers on the peninsula. Stocker Woolley was born on their farm in northern Great Neck. He purchased land in the Lakeville area from his father-in-law, William Tredwell, and in 1814 built a house that became the Woolley Homestead Farm. Stocker's house remains along with an icehouse built into a nearby hill. (Courtesy of Cecil and Estelle Jaffe.)

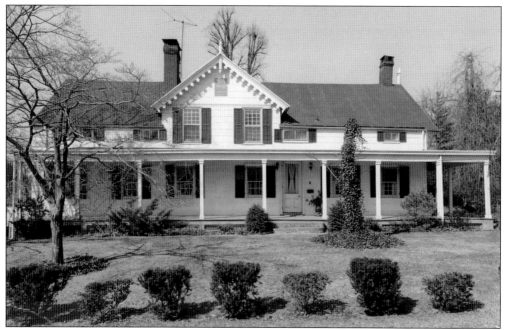

In 1814, Sam Warren built a one-story farmhouse, Maple Cottage, on Lakeville Road. John Dennelly later expanded the home, adding indoor plumbing and electricity. The cottage was the Locomobile headquarters for the 1905 and 1906 Vanderbilt Cup auto races. In the 1920s, Eddie Cantor bought 10 acres for his 17-room mansion. The Dennelly estate sold this house and the remaining land in the 1950s. (William Feminella photograph, courtesy of Jack Binder.)

Two

STEAMBOATS, HORSES, TRAINS, AND CARS

In the 1800s, the easiest way to travel to New York City was on the steamboats that sailed regularly from the north shore of Long Island. These boats served businessmen and visitors who came to enjoy the beautiful scenery and resort hotels on the peninsula.

In June 1880, the ferry *Seawanhaka* burned with 250 passengers aboard. At least 40 passengers were killed, including prominent Great Neck residents Abraham Skidmore and Hillard R. Hulbird. W.R. Grace, the former mayor of New York City and the owner of the Gracefield Estate, survived. James Udall, the owner of the Saddle Rock Grist Mill, was one of the owners of the *Seawanhaka*.

While steamboats continued to travel to Manhattan, the railroad was extended from Flushing to Great Neck in 1866. The line ended at the East River until 1909, when a tunnel was completed allowing direct access to Pennsylvania Station. The *New York Times* reported that commuters never tired of extolling the beauties of their Great Neck retreats, and Long Island attracted former city residents. Suburban development was underway.

After 1900, the Queensboro Bridge and the Brooklyn Bridge were opened. Livery stables and blacksmith shops gave way to automobile repair shops and car dealerships. Commuting to New York City had become much easier, and Great Neck was poised for change.

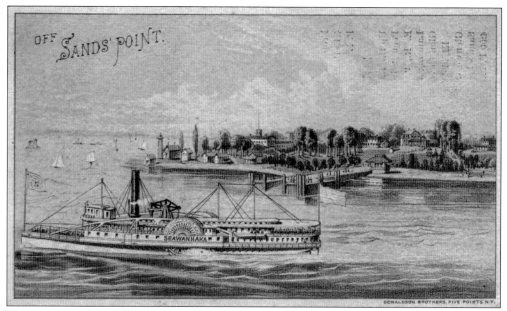

The steamboat *Seawanhaka* provided regular service between New York City and the north shore of Long Island until it burned in June 1880 while exiting the East River. Businessmen commuting to Manhattan and vacationers both traveled by boat. On the way from Manhattan, the boat stopped at Whitestone, Great Neck, Sands Point, Glen Cove, Sea Cliff, Glenwood, and Roslyn, according to the timetable on the other side of this card.

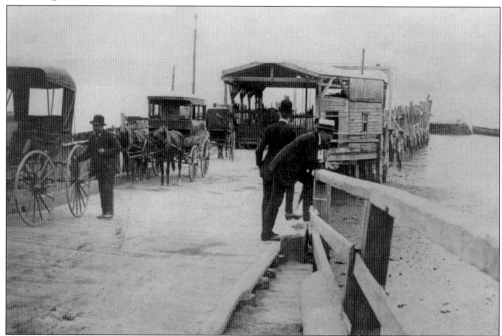

In the 1890s, Emily Childs, who sailed frequently on the steamship *Idlewild*, wrote, "After an hour's sail we landed at the dock which was filled with handsome carriages occupied by families of the men who were coming home from business." William Arnold, who lived nearby, was notorious for galloping to the landing and leaping aboard the steamer at the last second.

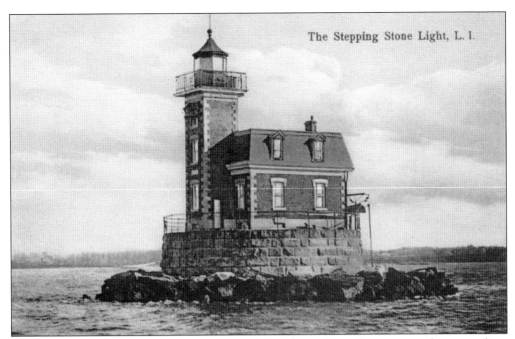

The Stepping Stone Lighthouse, in Long Island Sound near Kings Point, received its name from the boulders that keepers once used to access the lighthouse at low tide. Built in the Second Empire style by Irish bargemen and stonemasons from the Bronx, it was first lit in 1877. Findlay Fraser was the first keeper. The lighthouse continues to serve as an important navigational aid.

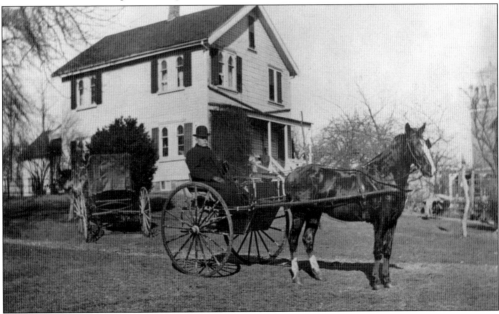

Thomas Shreeve, a livery driver, poses in front of his home at 114 Susquehanna Avenue, not far from the railroad station. Shreeve built his house in 1886, using lumber and arched window openings salvaged when a neighboring barn was torn down. The arched windows have since been replaced, but the house remains with few other changes. (Shreeve family photograph, courtesy of Great Neck Library.)

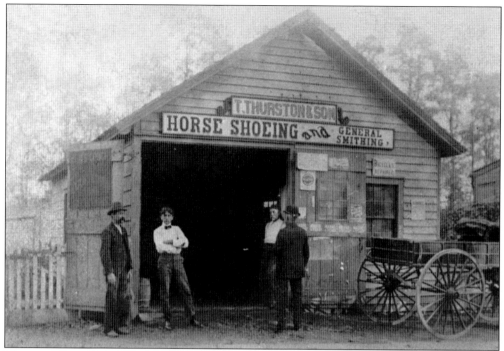

These men, standing outside the Thurston blacksmith shop on Middle Neck Road in 1899, are identified as, from left to right, Bill Chester, Jack Brown, Tom Thurston, and Oldfield Burtis. The Thurston shop was on the east side of Middle Neck Road, south of Hicks Lane, which was the center of business activity in the early 1900s.

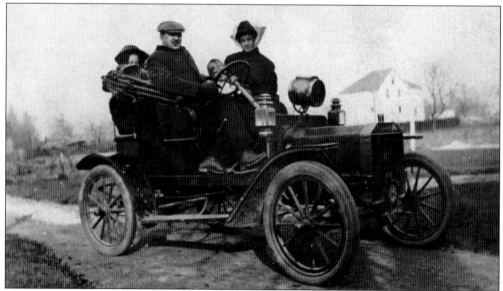

In 1908, a new automobile was a wonderful and rare possession. Here, members of the Fred Thurston family, who lived on Arrandale Avenue, pose proudly in their Ford Model R. Thurston's son later owned a bicycle shop at 377 Middle Neck Road. Timothy Reed remembered that Thurston gave patrons the proper tools and they had to fix the bikes themselves. (Thurston family photograph, courtesy of Great Neck Library.)

Great Neck L. I.
April 27/97
The wheels arrived this A.M.
Via R.R. Please ship
remainder of wagon C/o
I. Walker 76 Broad St. N.Y.
Via Str. Idlewild
Yours Schenck Bros.

The Schenck Bros. Carriage Shop, on Middle Neck Road, was in business as early as 1886. Members of the Schenck family, early landowners on the peninsula, also owned several farms. Their shop was on the east side of Middle Neck Road, south of Hicks Lane. It later offered automobile repairs and sales. This 1897 postcard message indicates how the Schenck Bros. shop transported its merchandise. "The wheels arrived this A.M. via R.R. Please ship the remainder of the wagon care of I. Walker, 76 Broad St., NY via Str Idlewild." The steamboat *Idlewild* traveled regularly from New York City to the dock at the end of Steamboat Road. (Courtesy of Alice Kasten.)

Grace Merritt Vicario and Giovanni Vicario owned a beautiful house north of the millpond at the southern edge of what is now the village of Kings Point. Members of the Vicario family posed frequently near their home in a variety of vehicles. Carlo Vicario, the son of Grace and Giovanni, is probably the little boy in the pony cart in front of the family house above, and also the young man below, driving the family car years later. These photographs were preserved by Henry Arbatowitz, a caretaker on the property. Giovanni and Grace Vicario both died in 1945.

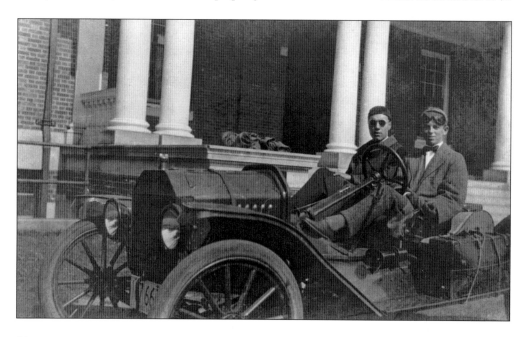

Before she married, Grace (Merritt) Vicario (above) was an 1892 graduate of the Women's Medical College of the New York Infirmary for Women and Children and a practicing physician. She continued her interest in medicine by organizing elegant balls in support of New York City hospitals, as Great Neck had no hospital. She was also an early commissioner of the Great Neck Park District. Giovanni Vicario, the publisher of two Italian newspapers in New York, had a law degree from the University of Naples. He served as a trustee of the village of Saddle Rock beginning in 1931. In the 1937 election, when only nine votes were cast, both Mr. and Mrs. Vicario were elected trustees. The Vicarios were taxpayers in the village, but not residents. A sign on the Vicarios' car (below) advocates women's suffrage.

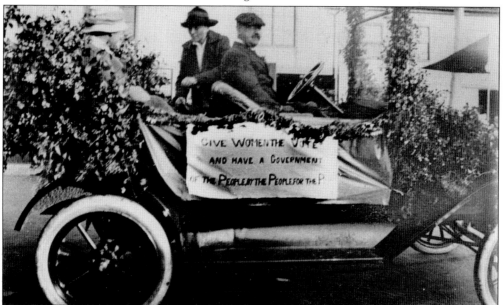

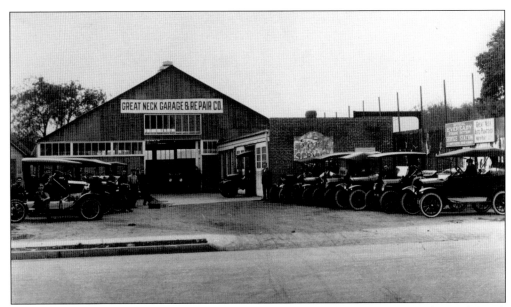

Great Neck Garage & Repair Co., on Middle Neck Road near the intersection with North Road, sold Fords as early as 1907. A few years later, many automobile showrooms were opened on Middle Neck Road. This repair shop, which still looks much like it did in this photograph, remains in business today after more than 100 years.

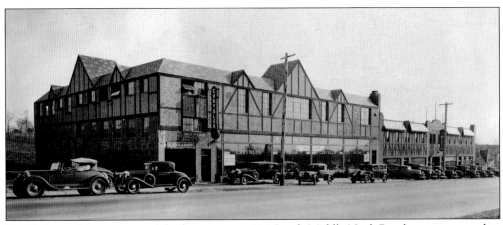

The Belgrave Motors automobile showroom, at 124 South Middle Neck Road, was converted to a light manufacturing plant during World War II. After the Belgrave Oldsmobile agency moved to Northern Boulevard, this building, essentially unchanged, served as a Ford dealership for many years.

This humorous photograph, symbolic of the change from the horse and buggy to the automobile age, was taken at the Mobilgas station on the corner of Middle Neck Road and Linden Boulevard. The manager at the time was C.W. Clark. This service station and several others have since disappeared from Middle Neck Road. (Clark family photograph, courtesy of Great Neck Library.)

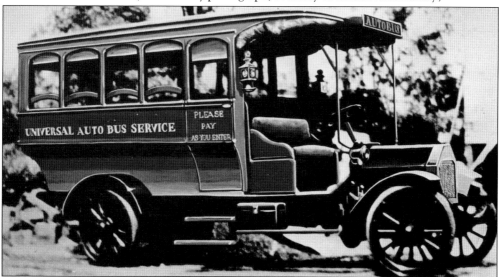

Universal Auto Bus operated on a regular route from Kings Point via Steamboat Road to the station. The fare was 5¢. This 1909–1910 bus had 14 seats and was built from a trolley body on a two-cylinder auto chassis. Streetcar service for the same route appears on early maps but was never constructed. There was trolley service on North Hempstead Turnpike from Roslyn to Flushing.

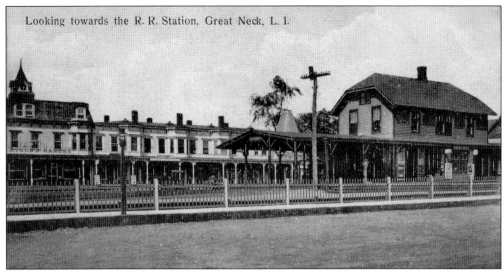

Looking towards the R. R. Station, Great Neck, L. I.

The railroad line from western Long Island to Great Neck was completed in 1866. Visible here behind the first Great Neck station is the Robertson Building (now known as Station Plaza North), along Railroad Avenue. This building remains today, with the addition of 20th-century storefronts and without the covered walkway. In 1889, the railroad line was extended across the peninsula and Manhasset Bay to Port Washington.

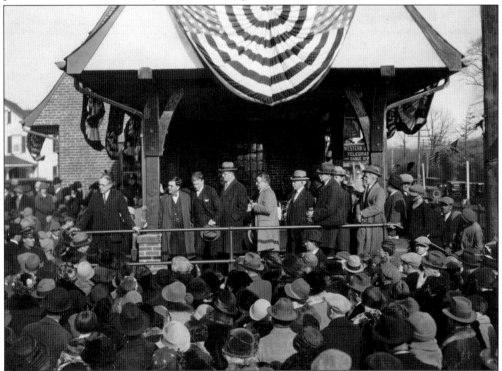

Great Neck photographer Alexander Culet recorded the grand opening of a new railroad station, which was commemorated by dignitaries on March 7, 1925. The new station was built in the English style by Ernest L. Smith at a cost of $50,000. On seeing the new station, Roswell Eldridge is quoted as saying, "Goodbye old Great Neck. This is a symbol of the passing of your beauty."

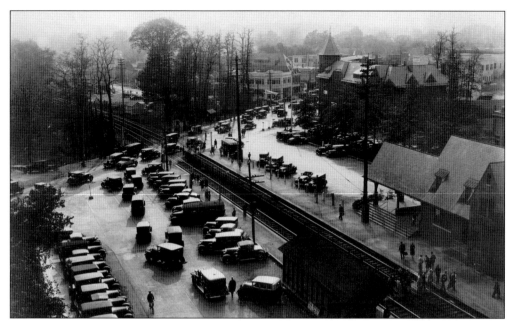

A photographer from the Takagi Studio on Grace Avenue took this photograph on May 22, 1930, from the Wychwood Apartments looking west across Middle Neck Road. Note the level-grade crossing of the railroad tracks, an obvious nuisance for the growing number of automobiles traveling on the main road of the peninsula.

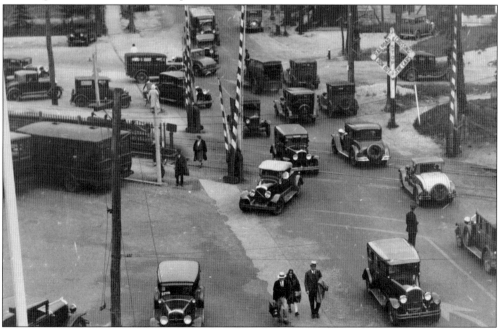

This view of the gates for the level railroad crossing on Middle Neck Road was photographed from the Grace Building on May 22, 1930, by a photographer from Takagi Studio. In 1933, residents objected to the railroad's plan to build an overpass to eliminate traffic congestion. A solution was found when William and Francoise Barstow donated $32,000 to cover the additional cost of lowering the tracks.

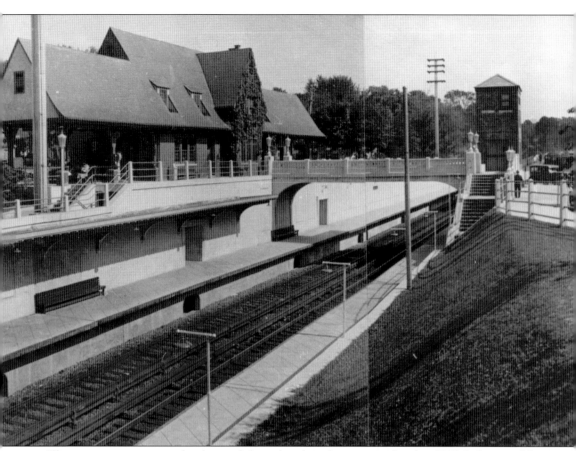

The construction project that lowered the railroad tracks was completed in 1935. In honor of the Barstows' contribution to the project, Seventh Street, at the east end of the station, was renamed Barstow Road. The project eased traffic, but residents were soon complaining about the lack of parking spots on Middle Neck Road. They were also unhappy to learn, in September 1935, that the Long Island Rail Road fare for a 60-trip ticket increased from $9.46 to $11.40.

Three

THE GRAND ESTATES

As Great Neck became more accessible, some of the smaller working farms gave way to large country estates. These landholders were generally part-time residents. They spent their working days in Manhattan and had multiple dwellings. Great Neck was often the site of just one of their country estates, as some of these owners had many such homes. But some spent the whole summer in Great Neck and became part of the community.

These estates encompassed dozens of acres, and many had dairy barns, greenhouses, and other accessory buildings. They all had multiple horse-drawn carriages, and then automobiles. The estates required vast staffs of chauffeurs, farmworkers, and housekeepers, among others. Thus, Great Neck was divided by a distinct class system: the rich were very rich and led a very different life than the poor. The estate owners had their own social circle, and many ended up marrying relatives of other local estate owners. The workers on the estates tended to come from the latest wave of immigrants and were hired literally off of the boat as they came to America.

The age of the grand estates came to an end in the late 1920s because of increased taxation and the necessity of maintaining large staffs. Real estate developers swooped in and purchased the estates, erecting dozens of homes on land where previously only one had stood. There are still reminders of these estates today, most notably in the names of streets and subdivisions. Very few of the grand dames still stand.

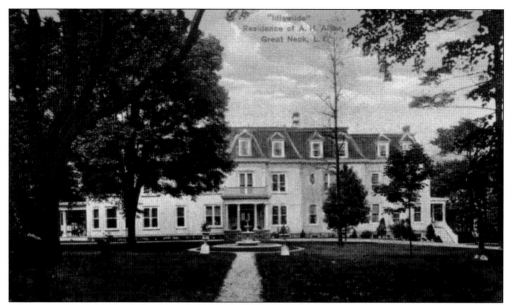

Alphonse Henry Alker, the son of a judge, graduated from Columbia Law School in 1873 and entered his father's law firm. In 1882, he married Florence Ward, the daughter of the founder of the Ward Line of steamers to Havana, and they constructed this grand home off of East Shore Road. The Alkers raised five children there and spent each summer at their Great Neck estate. (Courtesy of Alice Kasten.)

Alker, an enthusiastic yachtsman with extensive real estate holdings, was also vice president of a cement company and a member of Tammany Hall. According to his City College obituary, he was one of the handsomest graduates of the college, and an enjoyable companion. He was also generous; in the last 15 years of his life, his law practice worked almost exclusively giving free help to the needy. (Courtesy of Alice Kasten.)

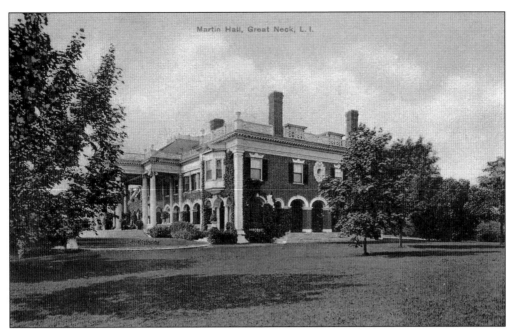

This mansion, known as Martin Hall, was owned by James E. Martin, an executive at Standard Oil. Martin died in 1905, leaving the property to his wife, Florence Brokaw Martin. She was the sister of William Gould Brokaw, who owned Nirvana, a neighboring estate. Florence married Dr. Preston Satterwhite three years later, and they entertained lavishly at this Great Neck home. (Courtesy of Alice Kasten.)

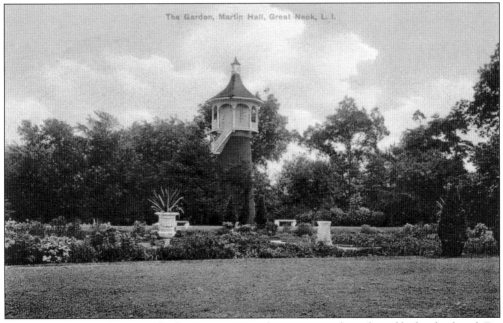

When Florence died in 1927, the home was put up for auction and purchased by her husband, Dr. Preston Satterwhite. He paid $610,000 for the 24-room house and the 32 acres, which included a stable, a garage, greenhouses, and living quarters for a large staff. The reception hall alone measured 50 feet by 70 feet. Among those present at the auction were Buster Keaton and Eddie Cantor.

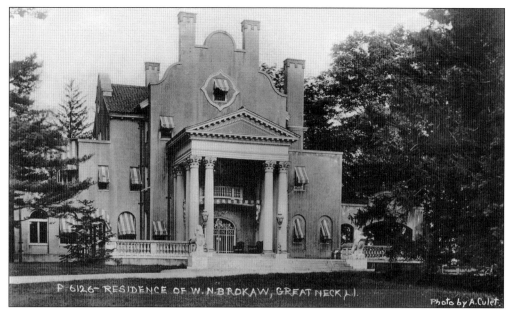

This 125-acre estate, Nirvana, was owned by sportsman and clubman William Gould Brokaw, who led a tumultuous private life. Brokaw was the son of the owner of Brokaw Clothing Stores and was a director of the Bowery Savings Bank. The estate was massive, and when Great Neck built its high school building in 1929, some of his land was condemned to become part of the school's footprint.

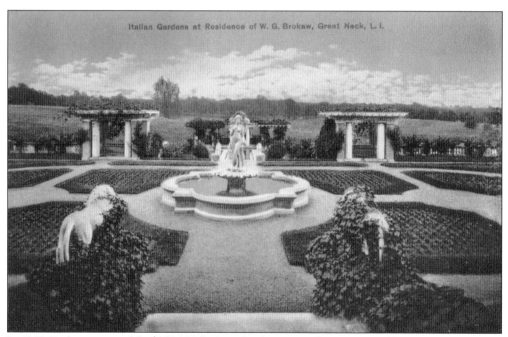

In 1903, Brokaw was sued for $250,000 for breach of promise of marriage, and his first marriage later ended in divorce. When he decided to marry Mary Morris Blair in 1907, no clergyman in the area would perform the ceremony, so it took place in Chittenango, New York, near Syracuse. That marriage also ended in divorce. In 1910, Brokaw was worth $4 million. (Courtesy of Alice Kasten.)

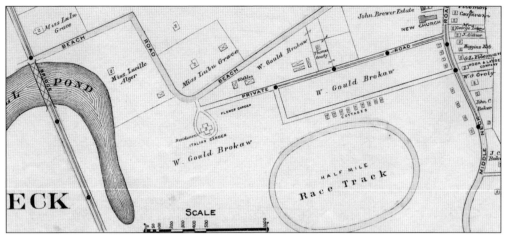

William Gould Brokaw's estate included a polo field and a half-mile horse-racing track. Brokaw did not hold down a job himself, but he helped to fund the Hibbard and Darrin automobile companies and was quite fond of racing both cars and horses. He was an active supporter and competitor in the Vanderbilt Cup auto races and was part of the horse set of Great Neck. (Courtesy of Alice Kasten.)

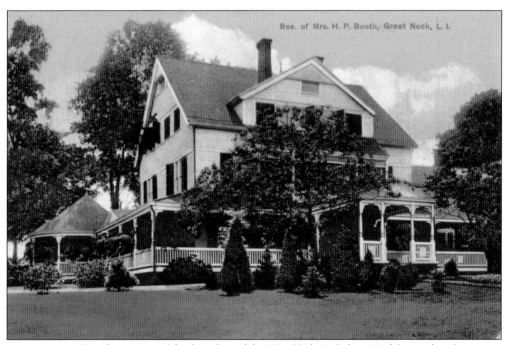

Henry Prosper Booth was one of the founders of the New York & Cuban Mail Steamship Company, also known as the Ward Line. The steamers ran regular service between New York City, Cuba, and the Bahamas, importing Cuban mahogany, tobacco, and molasses, as well as henequen, sisal grass, and coffee. He was also involved with other steamship lines, sugar-importing companies, and financial houses. (Courtesy of Alice Kasten.)

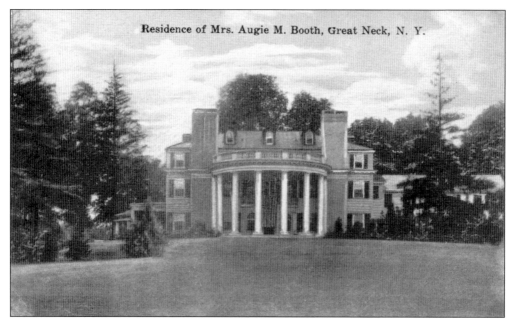

Residence of Mrs. Augie M. Booth, Great Neck, N. Y.

Angeline M. Booth continued to live in Great Neck after Henry Booth died in 1909. Her home and 50 acres were sold in 1923. The house had 16 rooms, and the property included a dairy, an icehouse, many different service quarters, with suites for both families and single men, a six-car garage, a greenhouse, and a flower-packing house, as well as a superintendent's cottage. (Courtesy of Alice Kasten.)

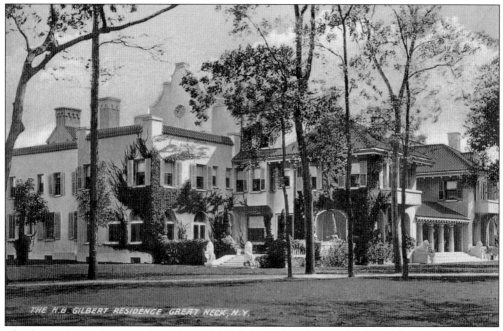

THE H.B. GILBERT RESIDENCE GREAT NECK, N.Y.

This home, located just north of Martin Hall, belonged to the family of wealthy merchant Henry Bramhall Gilbert, who was married to Lilla Brokaw, the sister of William Gould Brokaw and Florence Brokaw Martin. When Henry Bramhall Gilbert died in 1911, he left an estate valued at $15 million. The house, known as Sunshine, was demolished in the 1950s. (Courtesy of Alice Kasten.)

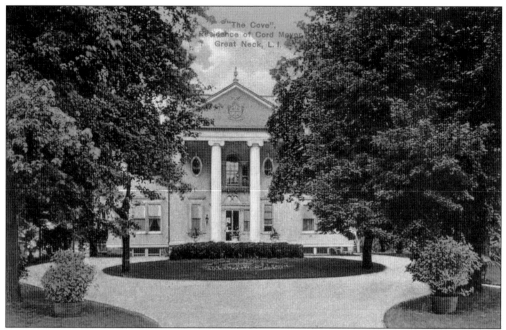

The Cove was the estate of Cord Meyer Jr., who inherited $7 million when his father died and turned that into an even larger fortune by buying farms and developing them into villages, most notably Elmhurst and Forest Hills. Also a politician, he served as the Democratic state chairman. Meyer died of ptomaine poisoning in 1910. The estate occupied the area around what is now Cove Lane. (Courtesy of Alice Kasten.)

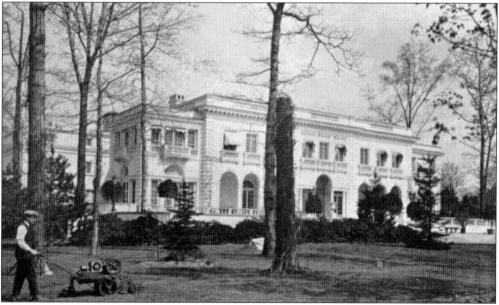

Walter Chrysler owned the mansion that is now known as Wiley Hall, the administration building for the United States Merchant Marine Academy. He purchased it, with its 12 acres, from Henri Bendel, and changed its name to Forker House, as Forker was his wife's maiden name. Chrysler came from the world of railroad mechanics to make his millions in the automobile industry.

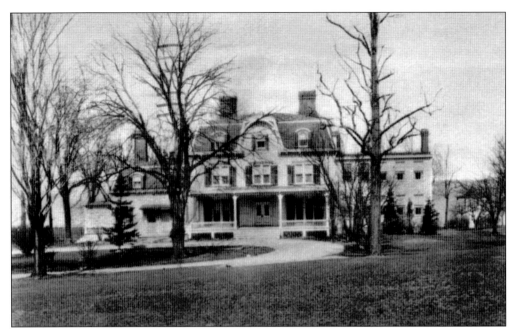

Walter Chrysler, bothered by the noise of the neighboring public bathing beach, purchased the home of actress Olga Petrova and offered it and $85,000 to the park district as a swap for the location of the offending land. The district refused, so he offered to construct two swimming pools, a bathhouse, and a pier. They refused again, and he gave the property to his son. This land later became Steppingstone Park.

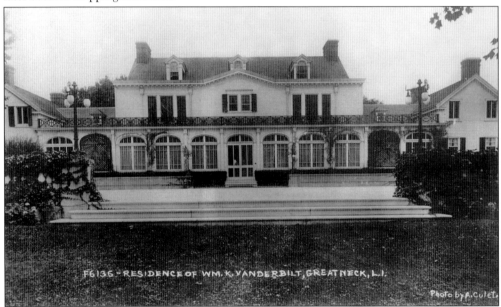

Deepdale was the estate of William K. Vanderbilt II, who inherited an immense fortune from his great-grandfather Cornelius. In the early 1900s, William began buying property around Lake Success, but was never able to purchase the lake itself. His homestead included a 38-room mansion, the core of which still stands, although some of it has been dismantled over time. (Courtesy of Jack Binder.)

William K. Vanderbilt II owned a second property, now the site of the Lake Success village hall. He was the prime force in the construction of the Long Island Motor Parkway, a privately owned road built for the purpose of auto racing, and he was responsible for constructing the Deepdale Golf Club and Course, seen here in 1926, which has become the village club at Lake Success. (Courtesy of Jack Binder.)

William Russell "W.R." Grace was the founder of a company that shipped sugar and guano from Peru to North America. After the company added a new shipping line, called the Grace Line, Grace became so wealthy that, in 1879, along with another Irishman, he helped to secure the national debt of Peru. He served two terms as the mayor of New York City in the 1880s. His estate, seen here, was the site of frequent steeplechase races. (Courtesy of Alice Kasten.)

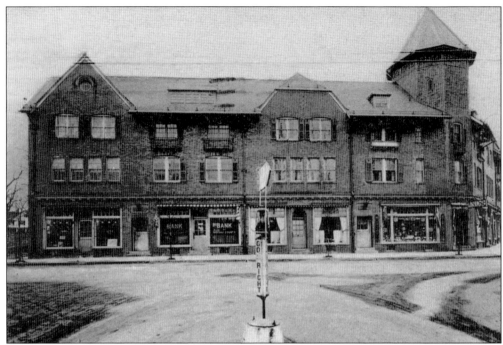

W.R. Grace commuted to Manhattan on the railroad. One day, he was not able to use the bathroom on the train, so he sued the Long Island Rail Road. He won the case, but the railroad did not have the $2,400 he had been awarded, so instead it gave him the land that is now Great Neck Plaza. This photograph shows the landmarked Grace building, which is still recognizable today. (Courtesy of Alice Kasten.)

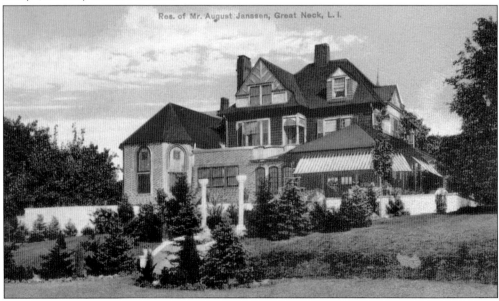

August Janssen was the owner of a string of restaurants worldwide, including the famous Hofbrau Haus in Manhattan, and was a founder of the Rotary Club. His estate, Locust Lawn, had 500 feet of frontage on the sound, a steel pier, many outbuildings, and was known for its collection of rare evergreens. He sold it in 1928 to Jessie Livermore for $250,000.

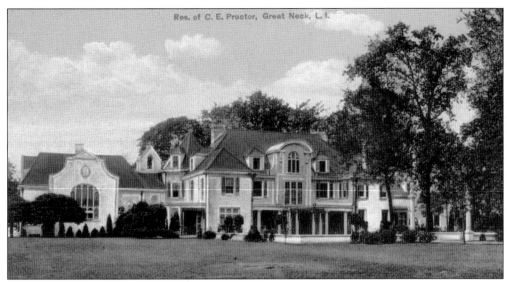

Shadowlane, the elegant 13-acre estate of Charles and Nona Proctor, was the site of many masked balls in the 1910s. News reports in the *New York Times* recount costume dances at which there were more than 100 guests, with 25 of them staying overnight. The house itself was featured in the 1915 volume *American Country Houses of Today*. The centerpiece of the home was a huge, world-famous organ imported from Spain. Charles was the grandson of the founder of the Singer Sewing Machine Company. A well-known artist, he was decorated by King Umberto of Italy for his paintings. Nona Proctor is listed in the 1914–1915 *Woman's Who's Who of America* with the terse phrase "favors woman suffrage." The photograph below was taken by Great Neck photographer Alexander Culet.

PERGOLA - C. RROCTOR, GREAT NECK, L.I. 2032
PHOTO BY CULET.

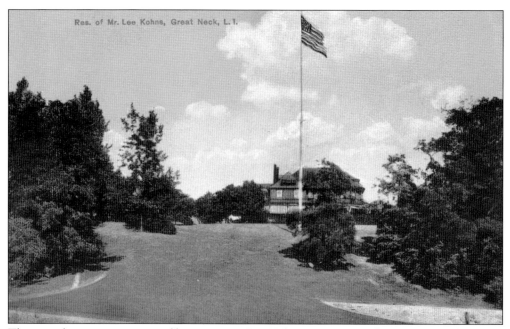

This was the summer retreat of businessman Lee Kohns. In 1921, workmen were readying the house for the season when an acetylene torch started a fire that burned the home to the ground. The Great Neck volunteer fire departments were not able to contain the fire, as the nearest hydrant was 1,000 feet away. Volunteers also came from the nearby homes of George M. Cohan and E.M. Scott.

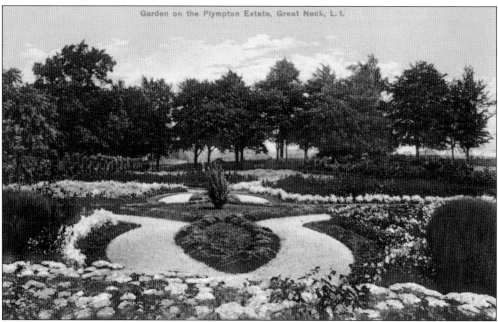

Great Neck estates were known for their formal gardens. These are the gardens of Gilbert Motier Plympton, a lawyer who was one of the founders of Bankers Trust. Sloops were the getaway vehicles of the early 1900s, and, in 1907, his estate was robbed of $2,500 worth of silverware. The empty drawers of the silver chest were found on the shore, where a sailboat had been seen loitering.

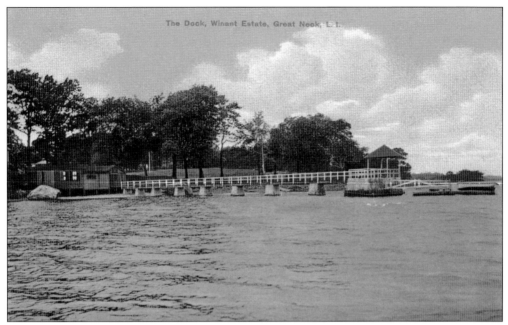

Most of the estates also had docks and boathouses. This property is located on Manhasset Bay and was first owned by Henry B. Anderson, a lawyer and the son of Cornelius Vanderbilt's legal advisor. In 1897, Anderson received a two-year mortgage for $6,000 at five-percent interest. The 16-acre property was sold to Daniel Winant for $115,000 in 1905.

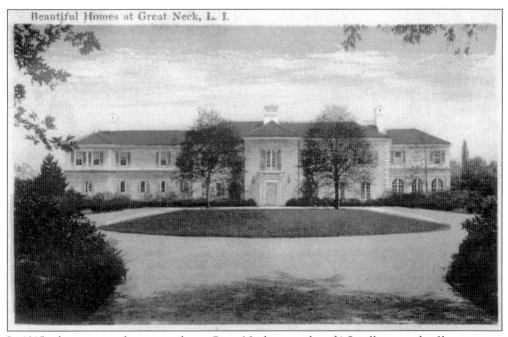

In 1915, a banner year for estate sales in Great Neck, more than $1.5 million worth of large estates changed hands. Among the sales were George M. Cohan's purchase of 14 acres, Sam Harris's purchase of another 14 acres, Henri Bendel's purchase of 10 acres, and a Mrs. Belmont's purchase of 18 acres. (Courtesy of Alice Kasten.)

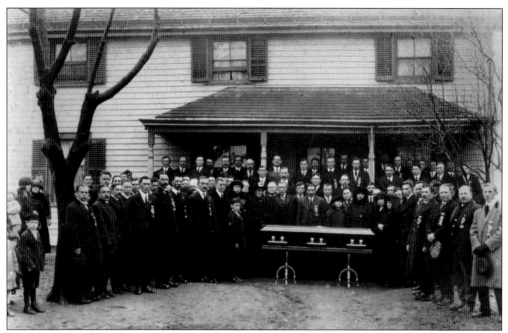

The estates were only able to operate on the backs of the working class. Among many waves of immigration, Great Neck saw the arrival of Lithuanians around 1912. They had been farmers in Europe, and many became gardeners for the grand estates. Here, the members of the Lithuanian community are attending a funeral for Edward Wesey. Funerals were held in the home of the deceased at that time.

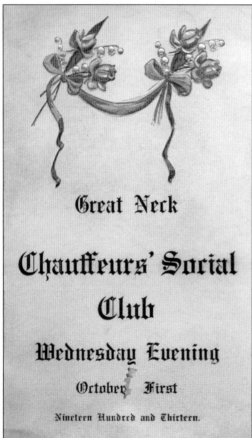

Great Neck

Chauffeurs' Social Club

Wednesday Evening

October First

Nineteen Hundred and Thirteen.

Even the hired help were entitled to a little recreation, and organizations grew up to accommodate this. This is the dance program for the 1913 Annual Ball of the Great Neck Chauffeurs' Social Club, held at the Alert Fire Hall. The chauffeurs held a highly respected position in the household hierarchy. They generally had their own apartments on the estates, which were large enough to accommodate a family. (Courtesy of Alice Kasten.)

Four

SCHOOLS AND LIBRARIES

Great Neck has always been known for its fine school system. In the earliest days of what became Great Neck, children were instructed by the local preacher, and, in 1714, the Episcopal Society for the Propagation of the Gospel in Foreign Parts funded a public school in the town of Hempstead, of which Great Neck was then a part. As this was quite far from Great Neck, the children of the larger-landed families were generally taught in private schools on their family property, sometimes together with the children of the neighboring family.

The first school on the peninsula was constructed on the property of Adam Mott in the 1700s. Mott was a successful tobacco farmer and a man of strong Quaker beliefs. The Society of Friends met at his home, and, eventually, a school was constructed there for the education of Quaker children. Unusual for the times, girls were also enrolled in this school, as this was a practice of the Quakers.

The true public school system was not established until 1814, when a plot of land measuring 65 feet by 34 feet was rented and the first public school was constructed. The land itself was purchased five years later for $20. At its peak, the Great Neck school system included two high schools, two junior high schools, and eleven elementary schools. Six of those elementary schools have been closed since the 1970s, the victims of declining public school enrollments. But the area's commitment to a rigorous quality education remains, and Great Neck schools are consistently rated among the highest in the nation.

The caption on this photograph describes this building as the "first school house" in Great Neck, but it was actually the third school. The first school was built in 1814 at the intersection of what are now Middle Neck Road and Wooley's Lane. It was replaced by a building that was located near the village green. After that building burned, this school was constructed at the corner of what are now Middle Neck Road and Fairview Avenue. (Courtesy of Alice Kasten.)

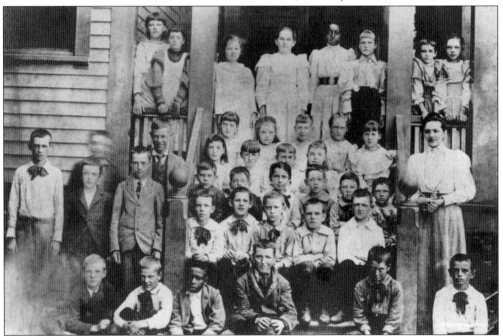

The small school at top was replaced by a larger building at the corner of Middle Neck Road and Arrandale Avenue. It originally taught students from kindergarten through eighth grade, but high school–level courses were added in the late 1800s. The first high school graduation took place in 1899, before the expansion to the building seen here.

The Arrandale site was home to a succession of school buildings over about 100 years. Since most of the population was centered in the north part of the peninsula, the schools were fairly centrally located. Here, children of the Baker family walk across the fields to get to school around 1915.

In 1914, the brick high school pictured was constructed between the old wooden Arrandale School and what is now Great Neck House. Students came from Manhasset and the Lakeville district, since those areas had no high schools. Some Great Neck students attended high school in Flushing. In 1921, the graduating class had only three students, as the dropout rate at the time was about 90 percent. (Courtesy of Alice Kasten.)

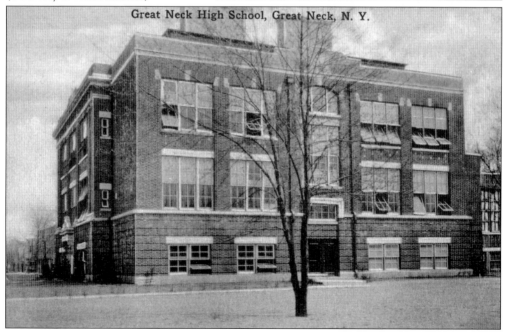

Great Neck High School, Great Neck, N. Y.

The wooden Arrandale School, constructed in 1900 at a cost of over $24,000, burned in 1920. When it was built, it housed the entire population of the Great Neck School District. However, the population, which had been concentrated on the north end of the peninsula, began shifting, and it was time for an additional school to be constructed farther south.

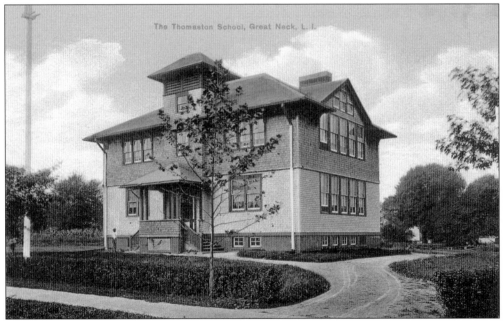

This five-room school was built in 1905 in the area that is now Kensington. Many residents of the northern parts of Great Neck chose to send their children here rather than to the Arrandale School. Later, additions were built and changes were made, and it became known as the Kensington-Johnson School. (Courtesy of Alice Kasten.)

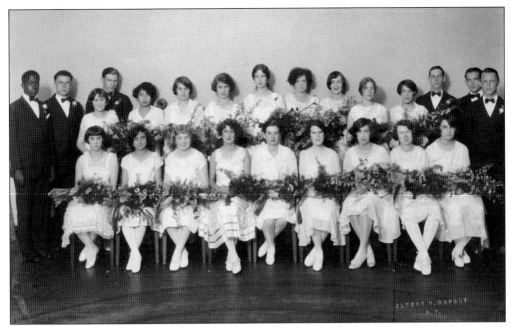

The graduating class of 1926 is seen here. Great Neck was experiencing a population boom, and, with more than 4,000 inhabitants, it was now large enough to appoint its own superintendent of schools. It was not the desirable district that it is today, and more than 20 years passed before an administrator stayed for more than a few years.

The increased population necessitated building a large high school, and the present Polo Road building was constructed in 1929. The land for the high school was acquired by condemning part of the William Gould Brokaw estate. At this point, the Great Neck School District only extended south as far as Cutter Mill Road. Beyond that was another school district, first called Success and later called Lakeville. (Courtesy of Alice Kasten.)

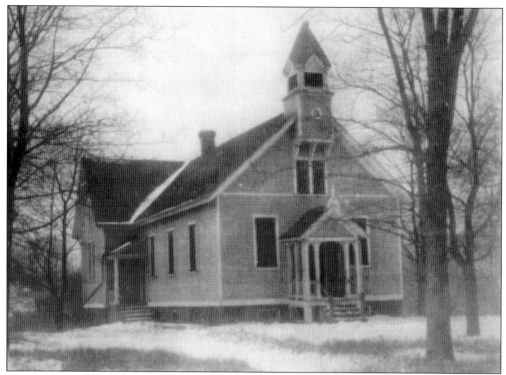

This is the first school of the Success district, located at Lakeville Road and the Long Island Expressway. In 1867, Success built a second school for "colored children" near the African Methodist Episcopal Zion Church. The district's name was changed to Lakeville, and it merged with the Great Neck School District in 1932. (Courtesy of Jack Binder.)

The 1935 kindergarten class at the Kensington school is seen here. The principal of the school was Marguerite Johnson, who served as a teacher for 8 years and then as the principal for 40 years. The school was later renamed Kensington-Johnson in her honor. She holds the distinctions of having read the last psalm in the school system, in 1961, and for delivering the last spanking, in the mid-1950s.

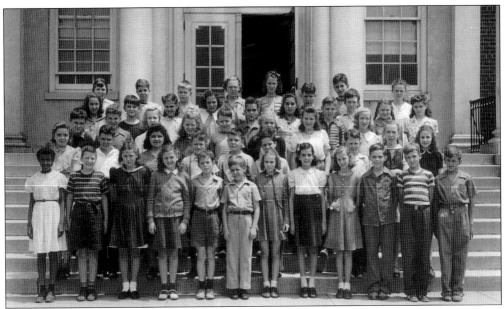

The 1940s and 1950s saw an elementary school building boom in Great Neck. Kensington's 1941 graduating class is seen here. In 1949, the Baker and Parkville schools were built, followed in the 1950s by the Saddle Rock, Cumberland, North Junior High, Clover Drive, Cherry Lane, and Grace Avenue schools. Later additions to the school system included Kennedy Elementary School, South Middle School, and South High School.

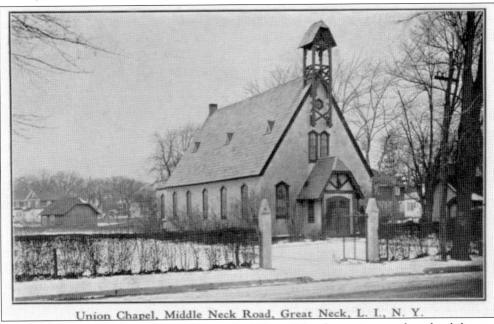

Union Chapel, Middle Neck Road, Great Neck, L. I., N. Y.

In 1950, the building that currently houses the Village School was given to the school district. This building was constructed in 1863 by the Allen family and used as a nondenominational church. Much of its congregation was siphoned off when All Saints Church opened, and the building later became a recreational outpost of the Woman's Club, and then a legitimate summer theater. (Courtesy of Alice Kasten.)

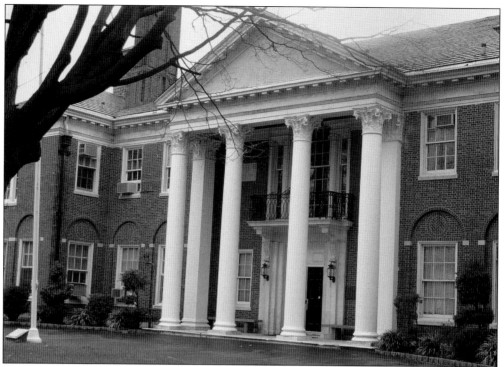

Industrialist Henry Phipps was a partner of Andrew Carnegie. He built this home, known as Bonnie Blink, in the 1910s to serve as his family's summer home. Phipps died in 1930, and, in 1949, the building and some of the land was donated to the school district. More of the land was eventually purchased, and the structure now serves the district as its administration building. (Courtesy of Alice Kasten.)

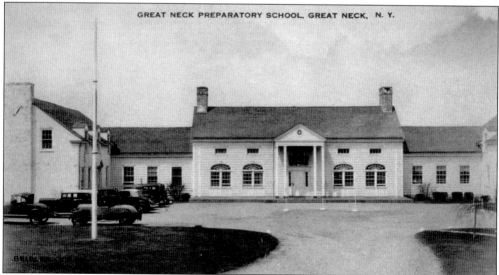

There were, and still are, many private schools in Great Neck, including Great Neck Preparatory School, seen here. It opened in the 1920s on Steamboat Road and was later renamed Buckley Country Day School. The school outgrew its location and moved to Roslyn in 1955. (Courtesy of Alice Kasten.)

Great Neck Library was first conceived by a group of women headed by Louise Udall Skidmore (later Eldridge, at right) in 1880. They held a fundraiser, in the form of a magic lantern show, and were able to raise $30, which later grew to $100. The first president of the library was Harriet Onderdonk (below), a descendent of the Mott family, who were early settlers in Great Neck, and the wife of a lawyer. Library board meetings were held at her home. They were held at night because there were men on the board who worked during the day. As the roads were poor, the ladies had trouble negotiating the journey. When these difficulties were pointed out to the gentlemen, they withdrew from the board so that the meetings could be held in the daytime. Mrs. Onderdonk remained president of the board until her death in 1904.

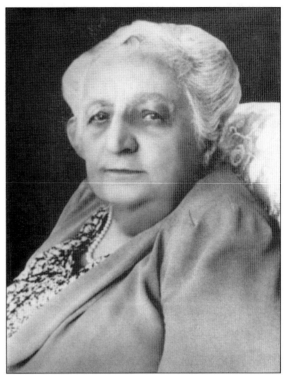

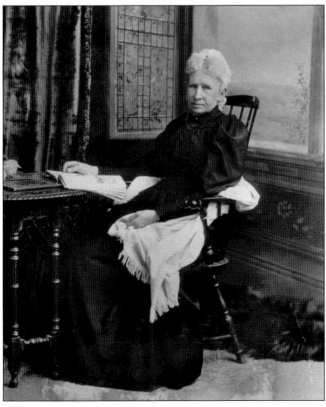

A fee of $10 per family was charged to become a member and use the library, which was originally housed in the dwelling of the librarian, Mrs. Daniel Gordon. The library soon moved from her home to the building of The League, a social club for men at 540 Middle Neck Road. The library was housed there from 1892 to 1907.

When more space was needed for the library, Louise Udall Eldridge and her husband, Roswell Eldridge, came to the rescue. They erected and donated the building now known as Great Neck House, which was the first true library in Great Neck. At that time, the library had a membership of 252 families, owned 2,500 books, and had a circulation of about 5,000. The Eldridges soon added several wings to the original building as circulation skyrocketed.

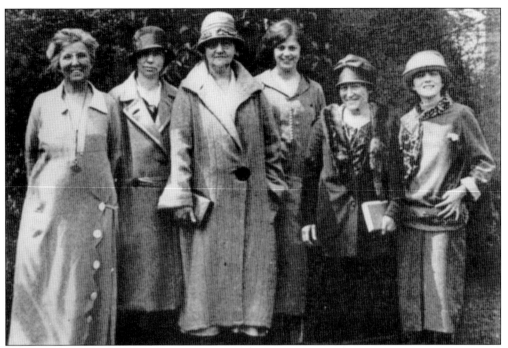

The library soon had annual expenses of $1,000. This group of library supporters was gathered for a fundraiser. They are, from left to right, librarian Mary Root, Mrs. Monroe Dyson Jr., Mrs. George V. Bullen, assistant librarian Anne Hedges, Nellie White, and Mrs. Harcourt E. Mitchell. In 1921, the school district added money in its budget to help support the library, and, by 1928, the library was completely supported by tax dollars.

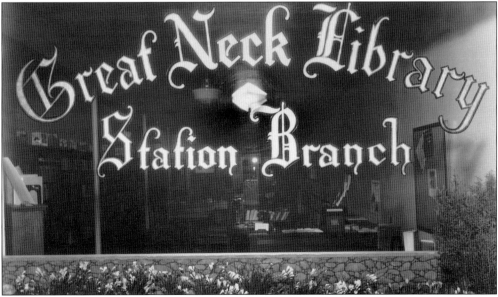

Great Neck is notable for the number of branch libraries in its small geographic area. The first of the branches opened in 1923 near the railroad station and has moved quite a bit over the years. The window of this library branch is seen here in 1939, when it was located at 118 Middle Neck Road. The Lakeville branch of the library opened in 1941.

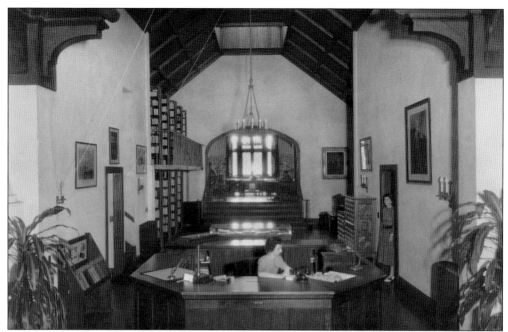

Library use expanded rapidly during the Depression years of the 1930s. In 1939, more than 160,000 books were circulated, and it became necessary to remodel the inside of the building. Staircases were widened and lighting was improved, as were the children's room and the staff work spaces. The library was used by the students at the Arrandale School, who were close enough to have regularly scheduled library periods during their school day. The use of the library was granted to anyone who paid taxes in the school district, and the annual fee was set at $5 for nonresidents. Some books were rentals, and subscribers paid 2¢ per day for popular fiction and 3¢ per day for nonfiction. Reserved books cost 5¢ per day. These two photographs of the library, shot by the Takagi Studio, were made into postcards and sold as a fundraiser.

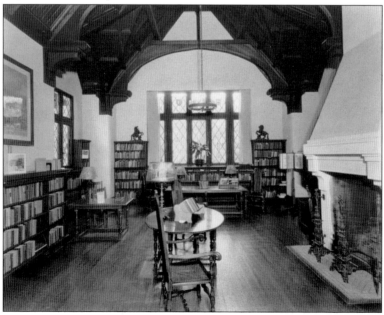

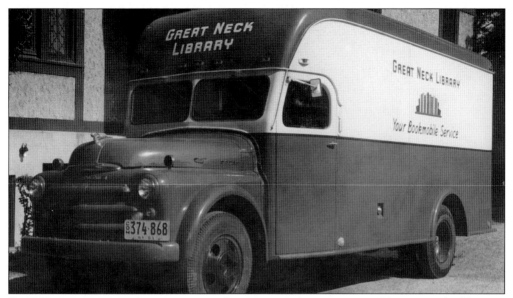

By 1942, increasing gas shortages meant that some residents were not able to visit the libraries, so the library came to them. This bookmobile made the rounds of the district until 1954. In that year, the Parkville branch of the library opened, giving readers three branch libraries as well as the main Arrandale building to choose from.

By the 1960s, the Arrandale site had become much too cramped, and the search for a new site was launched. The old site was appraised at $75,000. Among those interested in purchasing the property were Temple Isaiah, the Police Boy's Club, the Village of Great Neck, Carousel Child Care, the Community Theatre of Great Neck, and the Mobile Educational Museum of Ancient American Life. The building was finally purchased by the Great Neck Park District.

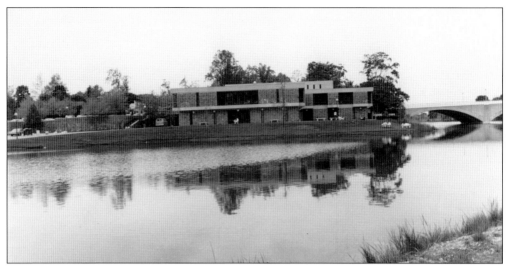

The present library building, on Bayview Avenue, opened in 1970 after 263,000 volumes had been moved into it. At that time, a series of art shows, concerts, movies, and other cultural events were initiated. Bus service was also provided to promote access to the population of the entire peninsula. The buses carried an average of 380 passengers per week.

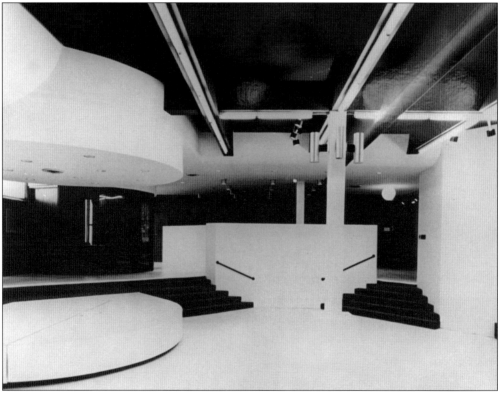

The new library also included a unique area geared for students from seventh grade up. Called Levels, it is seen here at the very beginning. It became a place for young people to learn about art, music, and theater, and to stretch their skills in handcrafts, and, later, in computers. It remains one of the few gathering spots for students from all four secondary schools in the district.

Five

GREAT NECK'S MAIN STREET

Middle Neck Road was yesterday's Main Street. However, in the 1800s, it was very far from the shopping district it is today. In the early days of Great Neck, there were two stores in what is now called Old Village, and they were both owned by the Hayden brothers. One was at Hicks Lane and the other was at Beach Road. The rest of the peninsula was occupied by farmland and private homes. The real shopping area at the time was in Manhasset, near Whitney Pond Park.

Over the years, business after business was built along this main road. Many of the first stores accommodated those who arrived by steamship and were built along Steamboat Road and on the nearby section of Middle Neck Road. Development was actually fairly slow in coming. For example, a 1919 map clearly shows only five businesses on the west side of Middle Neck Road between Steamboat Road (then known as Elm Point Road) and Arrandale Avenue. There were hardly any businesses south of Fairview Avenue.

The arrival of the railroad began to shift the focus of businesses toward the south, and later years saw the development of the area around the station. Suburbia had arrived; in fact, in 1955, when the TV family in *The Goldbergs* moved from the Bronx to the fictional Haverville, the opening sequence of the show was a view of Middle Neck Road.

This photograph shows the intersection of Middle Neck Road and Northern Boulevard around 1910. These roads, both unpaved here, are now six-lane highways flanked by gas stations, medical offices, stores, and apartments. This corner was named after a nearby landowner and lawyer, W. Clark Roe.

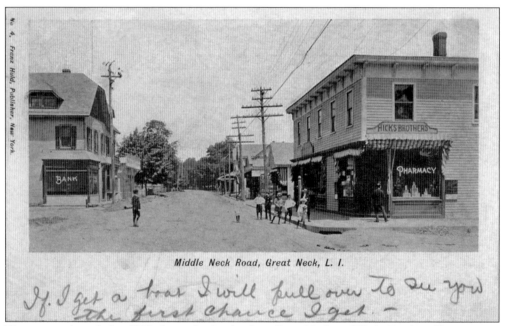

Middle Neck Road, Great Neck, L. I.

This postcard, mailed in 1908, shows the first bank in Great Neck and Hicks Brothers Pharmacy, at the intersection of Middle Neck Road and what is now Hicks Lane. This was the original business district of the peninsula. The pharmacy building had been the site of Nehemiah Hayden's store years before. (Courtesy of Alice Kasten.)

Mr _John B. Baxter_

Agricultural Implements
CROCKERY, HARDWARE,
Perfumery,
PATENT MEDICINES, &c., &c.

Bought of **S. E. HAYDEN,**
DEALER IN
Fine Groceries, Teas, Coffees, Dry Goods
HATS, CAPS, BOOTS, SHOES, &c.

TERMS CASH.—Interest will be charged after 30 days.

1887

June	11	To ball due on Bill rend.		16	71
"	"	" 13 bags loaned		1	95
"	20	" 1 lb Coffee			32
"	25	" 1 bott W. S. Sauce			35
July	2	" 2 " Oleve Oil		1	50
"	6	" 3 lbs Pork			30
"	19	" 1 " Butter			30
"	20	" 1 pck Borax			12
"	27	" 6 sheets Fly Paper			12
"	"	" 1 bag loaned			15
Aug	3	" 1 can Lard			36
"	8	" 1 lb Butter			30
"	12	" 3 bags loaned			45
"	22	" 9 Lemons			35
"	25	" 1 pt N. S. Oil			15
"	31	" 4 lb 5 oz Bacon			65
Sept.	1	" 25 " S Sugar		1	63
"	9	" 30 " S Sugar		2	10
				$ 27	71

Please sign and swear
to endorsed affidavit &
affix same to your claim
See Notice to creditors.
return time.

H. S. Moore

Samuel Hayden's store stood at the corner of Middle Neck Road and Hicks Lane. This billhead, dated 1887, was actually his account for John B Baxter, showing what Baxter had purchased over a three-month period and the cost of those items. Besides the noteworthy prices, it is interesting that Baxter never bought more than one item on a given day. (Courtesy of Alice Kasten.)

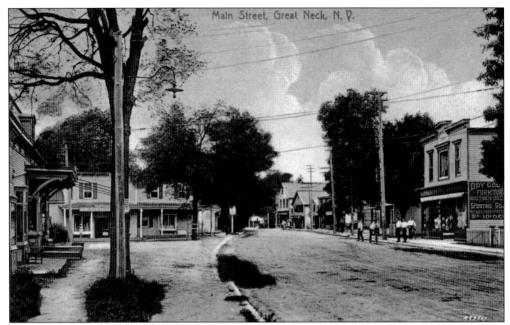

The right side of the intersection of Middle Neck and Beach Roads was home to the Ninseling & Sons barbershop and store, which sold dry goods, furniture, and sporting goods. Farther down the street is the canopy of the LeCluse Brothers general store. Owner Egbert LeCluse, a member of the Alert Fire Company and a justice of the peace, was also responsible for bringing telephone service into the community. This photograph was taken before 1909.

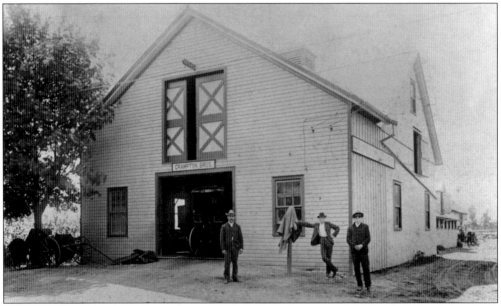

The Crampton Bros. livery business operated on Hicks Lane near Middle Neck Road from 1913 until 1921, when the family opened a road construction firm with a dock on East Shore Road, which continued in business for more than 50 years. Joseph Crampton, who was the president of the family business as well as a realtor, was instrumental in the incorporation of the Village of Great Neck.

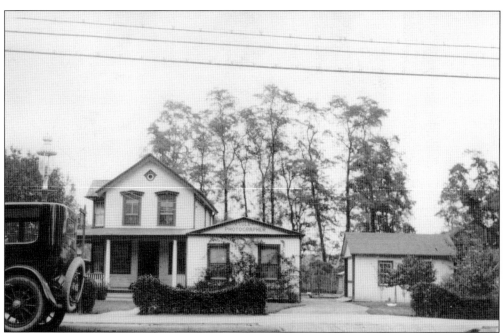

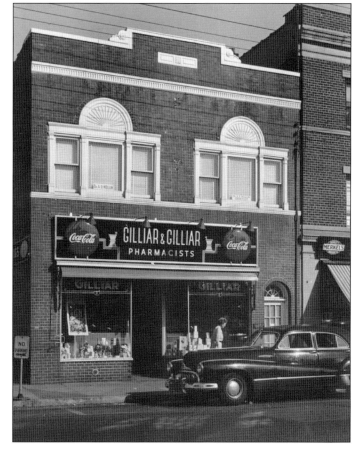

Alexander Culet's photography studio (above) was located at 325 Middle Neck Road. Culet, born in France, established himself as a fine photographer and took many of the photographs still found on real-photo postcards of Great Neck from the 1910s and 1920s. Several of the photographs in this book were taken by him.

The Gilliar family is one of many local success stories. The first family member to come to Great Neck was hired off of the ship at Castle Garden in 1857 to work on the Onderdonk farm. The woman he met that day—and married a week later—was also hired to work on the farm. About 100 years later, the Gilliar name was visible on two local drugstores and a liquor store.

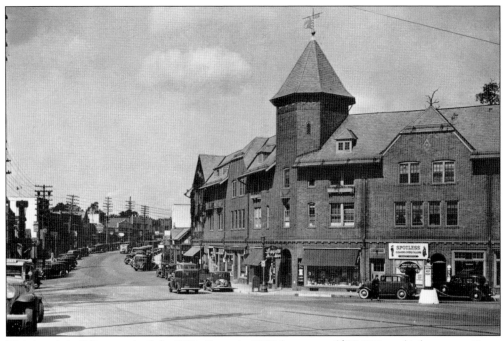

This iconic building was built by W.R. Grace in 1913 for a cost of $90,000, and it became a Great Neck landmark. The familiar figure of the jester, an eight-foot-tall bas-relief by artist Howard Goldberg, was not added to the building until the 1980s. The building is listed in the National Register of Historic Places.

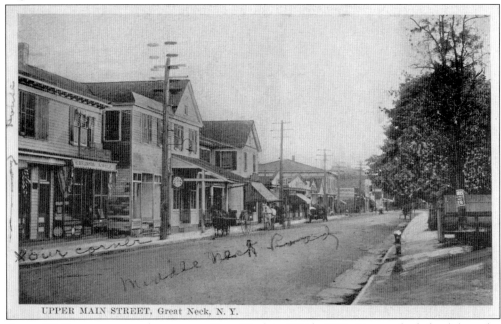

UPPER MAIN STREET, Great Neck, N. Y.

Avram Wolf was encouraged to move to Great Neck in 1891 by W.R. Grace, who helped the tailor get established here. Wolf then branched out, opening this real estate office, from which he also sold insurance. Great Neck's first Jewish man, Wolf anglicized his first name to Abram. His son I.G. Wolf was also a well-known real estate agent. (Courtesy of Alice Kasten.)

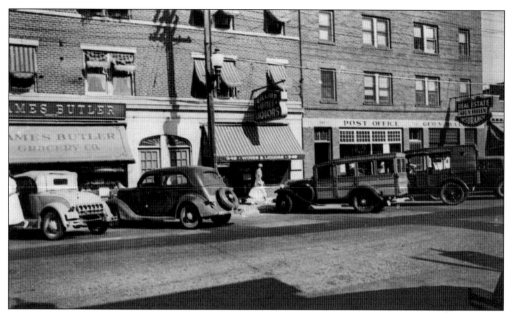

The post office in the village of Great Neck has not always been where it is now. Here, it was located at no. 347, next to Gilliar's liquor store. The James Butler grocery chain (left) had more than 1,000 stores; by the early 1930s, it was the second-largest grocery chain in the New York area, as only A&P had more stores.

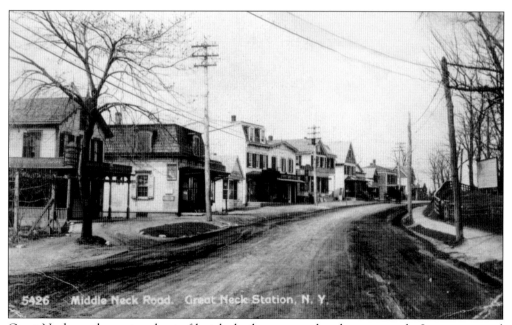

5426 Middle Neck Road. Great Neck Station, N. Y.

Great Neck was home to a host of hotels, both year-round and summer-only. It was a natural destination for city dwellers, who would arrive by steamship or railroad to rest awhile in the country. On the left is Thomaston House, later known as the Evans Hotel. Many rooming house postcards sent by vacationers pointed out the location of their room on the card.

Louis Gregory's electrical shop was located at 36 Middle Neck Road. The Gregorys are another family with wide roots in the community. One family member owned a coal and lumber supply company on Cutter Mill Road, and another owned the home on Northern Boulevard that later became the North Shore Steak House. There is still a store bearing the Gregory name in Great Neck today.

The staff of the Venzke Furniture Store poses for a photograph outside the business, located at 83 Middle Neck Road, in 1928. Note the Masonic temple next door. This was just south of Maple Drive (then Maple Street) in Great Neck Plaza. The 1919 map of Great Neck lists the Masonic temple as the "Community Church."

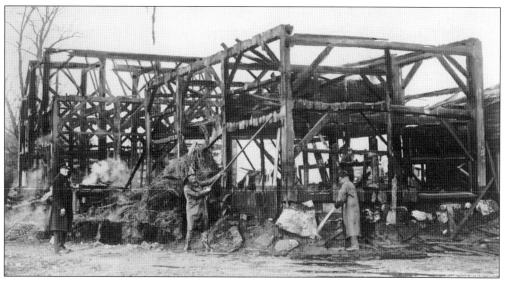

The Belgrave Riding Academy was located at 18 South Middle Neck Road. This photograph shows the steel structure after an April 1931 fire that killed 11 horses. The academy, which rebuilt after the fire, was a source of recreational horses for the community. In 1933, a horse jumped the fence and was electrocuted when his horseshoe touched the third rail of the nearby tracks.

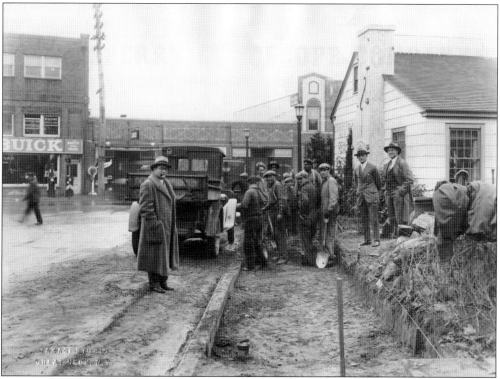

These men are laying the sidewalk on Grace Avenue, with Middle Neck Road in the background. Grace Avenue did not cross Middle Neck Road in 1929, when this photograph was taken. In 1978, the low building in the center was razed to allow traffic to continue to the parking areas. Note the gas pumps on the left, outside the Buick dealership.

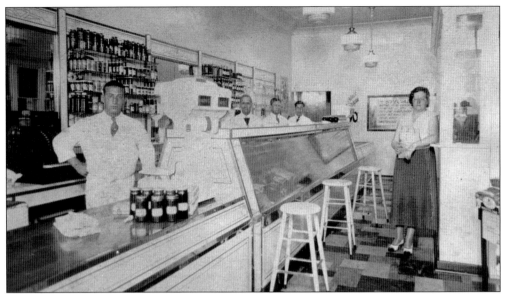

This 1932 photograph shows the inside of Hanophy's Meat Market, located at 48 Middle Neck Road. James Hanophy, the original owner, lived on Third Street (now Bond Street) and died in 1930. His children carried on his business. There were many food stores on Middle Neck Road in the early days. Now long gone are Bohacks, the A&P, Key Food, and Gristedes, to mention just a few.

The building boom is evident in this late-1930s photograph of a busy Middle Neck Road, as there are three real estate agencies in a row. It was around this time that the grand estates were giving way to subdivisions. On the right, the railroad crossing had been eliminated, dating the photograph to after 1937.

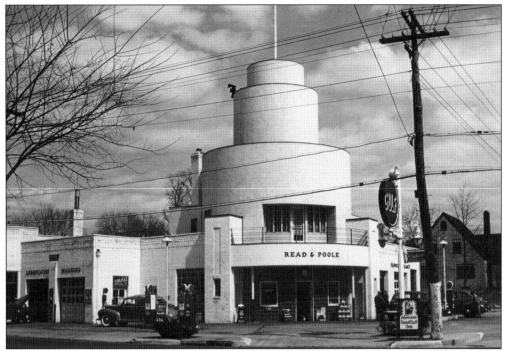

This memorable building opened in 1938, housing an Oldsmobile showroom and a Gulf service station. The building cost $50,000 to construct. The upper part was a 2.5-room tower apartment, which included a living room that was 26 feet in diameter. The first gas station's first customer was Mrs. Joseph Price of Colgate Road, who ran out of gas right in front of the station. (Courtesy of Alice Kasten.)

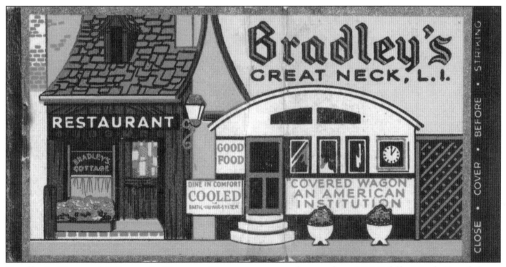

Bradley's Covered Wagon & Cottage Restaurant was located at 26 Middle Neck Road from 1927 through the late 1930s. Bradley's was two eateries in one: a modern diner with a connected upscale restaurant. The newspapers of the era report that the management welcomed constructive criticism. This elegant matchbook dates from the 1930s. (Courtesy of Alice Kasten.)

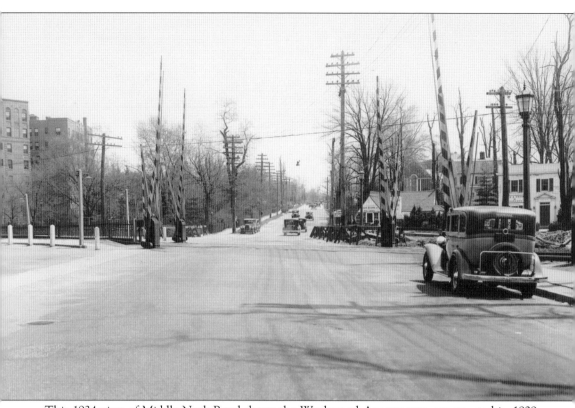

This 1934 view of Middle Neck Road shows the Wychwood Apartments, constructed in 1929, on the far left. The tracks had not yet been lowered, and stores did not yet line South Middle Neck Road. The Christian Science church can be seen south of the railroad in the distance. The white building on the right housed a real estate business belonging to the Bakers, as well as an insurance company. The freestanding building is yet another real estate agency, as development was a booming business in Great Neck in the 1930s. These buildings were razed to make room for a shopping center built by Sol Atlas, which is still located at the intersection of Middle Neck and Great Neck Roads. (Courtesy of Alice Kasten.)

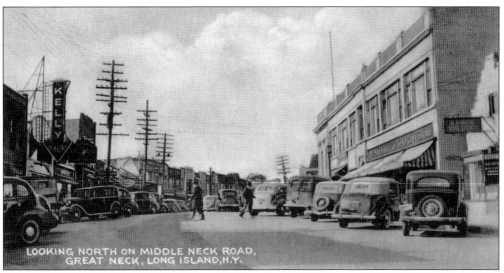

This 1940-era postcard view shows a busy Great Neck Plaza scene, just north of the Grace Building. The Woolworth's, on the right side of the street, moved to a new shopping center, the North Shore Mart, in 1951. It remained there until the early 1990s. (Courtesy of Alice Kasten.)

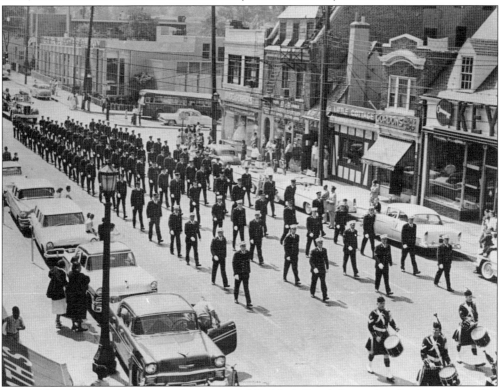

This 1950s photograph of a parade along Middle Neck Road shows the clearly recognizable intersection of Great Neck Plaza. Notable are the Key Food supermarket, at 30 Middle Neck Road, and a corner of the awning for Womrath's bookstore, across the street at 39 Middle Neck. The Grand Union supermarket was conveniently located in the North Shore Mart, the shopping center where Waldbaum's supermarket is today.

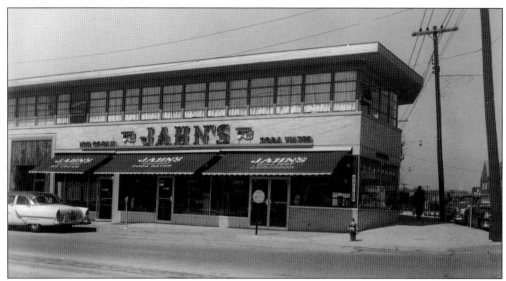

Jahn's Ice Cream parlor was at the corner of Middle Neck and Great Neck Roads in the mid-1950s. The chain was famous for its old-fashioned appearance and its massive ice cream concoctions. Another former Great Neck ice cream favorite was Friendly's, which began in the village of Great Neck in the 1970s. This building still stands, and while it is now home to a bank, it unmistakably shows its roots as an ice cream parlor.

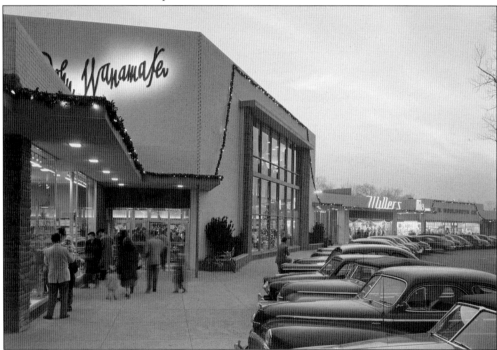

North Shore Mart was constructed by Sol Atlas in 1951. This shopping center was the first of its kind on Long Island, and boasted a 500-car parking lot. The original tenants included branches of Wanamaker's, Woolworth's, Grand Union, Miles Shoes, and Pennsylvania Drug Stores. Horn & Hardart moved in the following year. Wanamaker's gave way to Stern's and then to Gertz, which finally closed in 1979. (Courtesy of the Library of Congress.)

Six

THE NINE VILLAGES

Nine villages and several unincorporated areas make up Great Neck, which has four zip codes, three fire districts, and several water and sewer districts. The large area is united by one library district and one school district. The villages incorporated between 1911 and 1931, as suburban growth and demands for zoning restrictions increased.

In 1911, Louise Udall Eldridge incorporated her estate as Saddle Rock, which required a special act of the state legislature because of the estate's small population. Her husband, Roswell Eldridge, was mayor until 1926, when Louise became the first woman to serve as a mayor in the state of New York. She died in 1947 while running for reelection.

The Thorne estate, developed by the McKnight brothers, was incorporated later in 1911 as Great Neck Estates. About the same time, Charles Finlay and E.J. Rickert began advertising Kensington. Many of the grand estates were on the verge of development when Kings Point was incorporated in 1924. At that time, the residents associations of Kennilworth, Elm Point, Grenwolde, and Gracefield had already formed in an attempt to manage change.

The area known as the Old Village was incorporated in 1926 as the Village of Great Neck. Lake Success, previously known as Lakeville, incorporated the following year. Three villages in the station area incorporated in 1930 and 1931. Great Neck Plaza chose not to use the name Thomaston, which had originally been assigned to the area by W.R. Grace.

Russell Gardens was built on 90 acres, which Frank Knighton and Ralph McFee purchased from Capt. Frederick Russell, a former tugboat captain. The village of Thomaston, which included the Great Neck Improvement Company developments, chose to retain the name of the station area. Several areas of the peninsula, such as University Gardens and Great Neck Gardens, remain unincorporated within the town of North Hempstead.

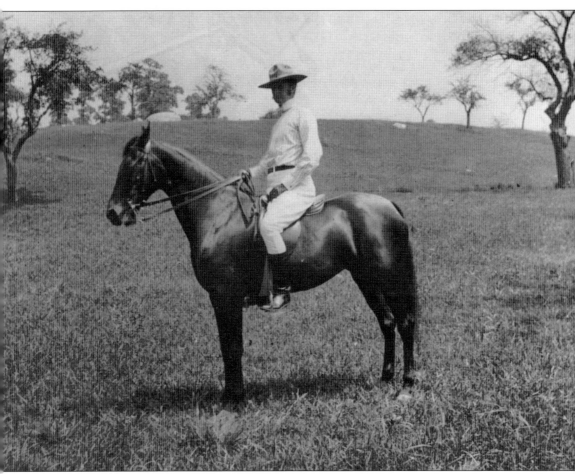

Roswell Eldridge, seen here, raised saddle horses. He was a wealthy financier who was first employed by James Udall, who owned the estate that later became the village of Saddle Rock. Eldridge married Udall's granddaughter Louise, and together they developed many of the institutions in the Great Neck community they loved. He was the mayor of Saddle Rock from its incorporation until 1926, when he was succeeded by his wife. Having been landscaped by the Olmsted firm and Beatrix Ferrand, the gardens on their 167-acre estate were considered one of the showplaces of the North Shore. If, as it was said, Eldridge dreaded seeing his community succumb to the bustle of modern life, he would have been distressed to learn that much of his property was sold in 1936 for a development of 340 homes.

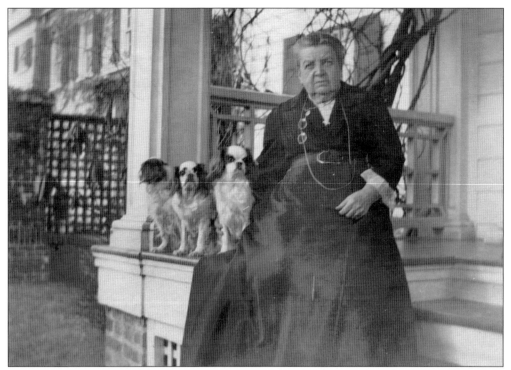

Louise Eldridge poses with three puppies on the porch of her home, where her husband, Roswell, raised King Charles spaniels. They often traveled to Europe, where Roswell loved to hunt. Near the end of her life, Louise donated a portion of her estate for a much-needed hospital. The hospital was built elsewhere, however, when the Saddle Rock site was deemed too small.

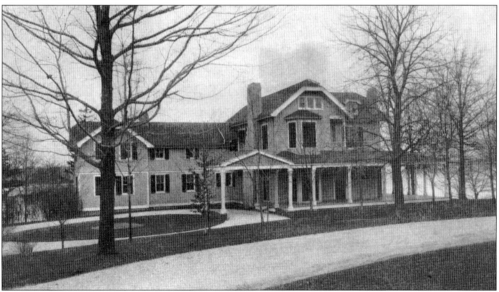

In 1630, the Thorne family, who were among the earliest European residents in the area, purchased a large tract of land on the west side of the peninsula. Alex Thorne's home, seen here, was built on that land. The property was sold in 1909 to the McKnight Realty Company. In 1911, the area was incorporated as the Village of Great Neck Estates.

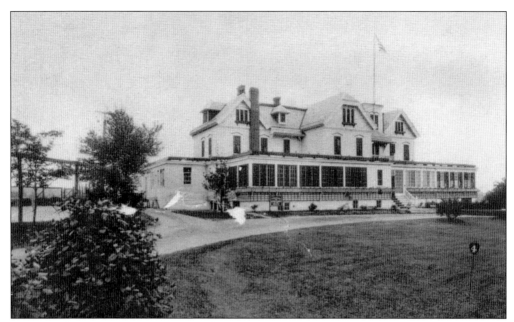

A nine-hole golf course was developed in 1912, one year after incorporation of the Village of Great Neck Estates. An expanded 18-hole course, the Sound View Golf Club, seen here, was host to many national and international tournaments. Famous golfers and noted Great Neck residents, including W.C. Fields, Ring Lardner, and Bayard Swope, played there. The course was sold for development in 1939.

Construction began on the Kenwood Apartments, on the Middle Neck Road border of Great Neck Estates, in 1925. It was advertised as 100-percent cooperative. Charles Finlay, the owner, planned 66 units, a rooftop garden, and a restaurant. He even planned for room service. Advertisements promised a Park Avenue atmosphere.

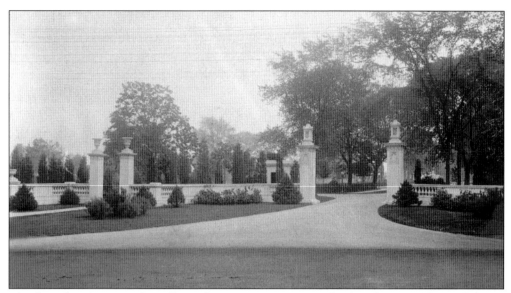

The formal entrance to the village of Kensington remains a landmark on Middle Neck Road. Developers Charles E. Finlay and E.J. Rickert wrote that their development would suit the refined man of modern taste, especially if he was an out-of-doors man with a family. The development, which was built on the Deering property and reached all the way to Manhasset Bay, was only four minutes from the railroad station.

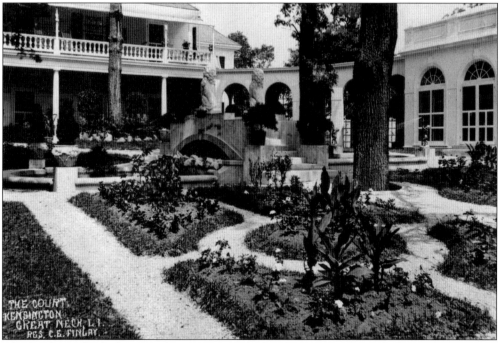

The developers built their own homes just inside the Kensington gates, which were copied from London's Kensington Gardens. Charles Finlay's home, Bonnie Manse, was designed by Little & Brown and featured the beautiful gardens seen here. E.J. Rickert's impressive residence was later owned by Luis Martinez Valverde. After Valverde's death, the abandoned building became known to local children as the haunted house. It was replaced in 1969 by an apartment building.

Lottie Blair Parker, the author of many plays, including *Way Down East,* lived in this remarkable Second Empire–style house in Kings Point, overlooking Manhasset Bay on East Shore Road. Herbert Bayard Swope, the editor of the *New York World,* rented the home from 1921 to 1928. Swope's frequent lavish weekend parties attracted a wide variety of celebrities, including F. Scott Fitzgerald and neighbor Ring Lardner.

The Hicks family is well known in Great Neck. In 1823, Benjamin Hicks Sr. bought property along the border between the villages of Great Neck and Kings Point (now Hicks Lane), reaching to Manhasset Bay. He was described as a man of energy, a believer in the principles of the Society of Friends, and an upright citizen who despised public display.

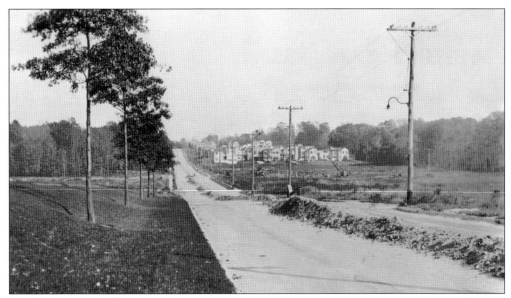

In 1926, when the Village of Great Neck was incorporated, housing developments appeared on the former Baker farm, including the Spanish-style homes built by Centre Villa, Inc., on Baker Hill Road. Four models of stucco houses with tile roofs were designed by Arthur E. Allen of Jamaica, New York, to be sold for between $13,950 and $14,950. (Baker family photograph, courtesy of the Great Neck Library.)

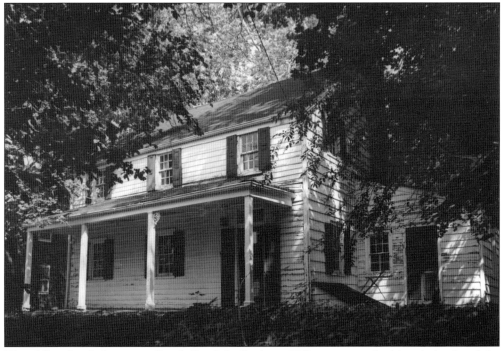

This Allen family house on Beach Road, built about 1750, was named a historic landmark by the Village of Great Neck in 1977. The house, now restored, was occupied by the Allen family until the end of the 19th century. It is a rare example of an 18th-century farmhouse virtually unchanged since it was built.

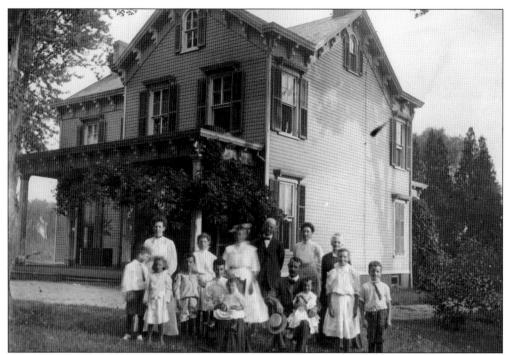

In 1963, at age 94, Robert Ellard wrote a document cherished by local historians: *Old Great Neck*, a detailed description of the Great Neck of his childhood. This photograph of the Ellard family home, in the village of Great Neck, also known as the Old Village, was printed from a glass-plate negative. (Ellard family photograph, courtesy of the Great Neck Library.)

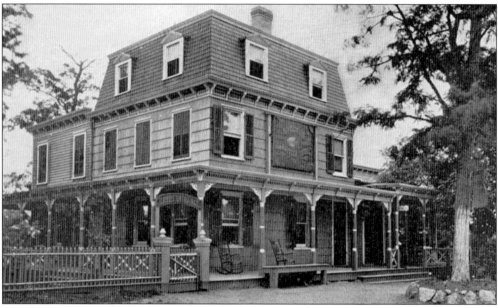

An advertising brochure for the Lake Success Hotel emphasized that the scenery and boating on Lake Success could not be equaled by any nearby resort. The hotel, which could accommodate 35 guests, had a shooting gallery and facilities for fishing, boating, and bathing. The lake was stocked with pickerel, perch, and eels.

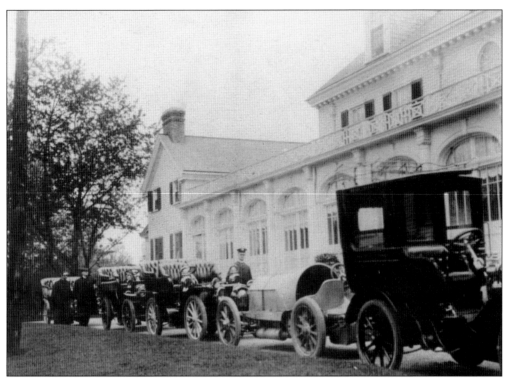

William K. Vanderbilt II is seen on the extreme left of this 1905 photograph of his home, Deepdale, on Westcliff Drive in Lakeville (now the village of Lake Success). An auto racing enthusiast, Vanderbilt built the Long Island Motor Parkway, a toll road that passed close to his home, for the Vanderbilt Cup races. Portions of the road remain. (Courtesy of the Suffolk County Vanderbilt Museum.)

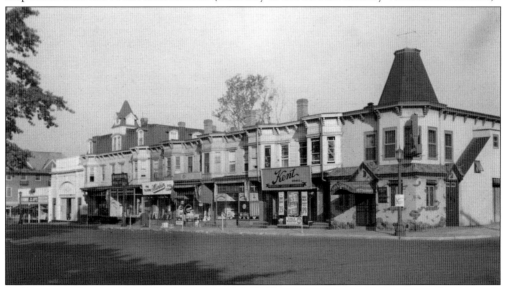

Buildings on Station Plaza North in Great Neck Plaza, seen in this 1950s postcard, were built before 1900 as the Robertson Building. The Club Tavern Restaurant, on the corner, is now a Dunkin' Donuts. The white building on the left, which has since been razed, was home to the Mayfair movie theater, a Hudson showroom, and the service men's club during World War II.

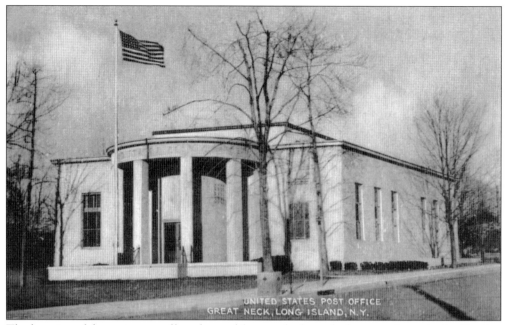

The location of the main post office changed frequently through the years. It was in the Hayden brothers' stores, in the lobby of the Wychwood building, among other locations. With the benefit of Works Progress Administration funds, this new main post office, designed by Louis Simon and William Dewey Foster, opened in 1939 at 1 Welwyn Road. The handsome building is listed in the National Register of Historic Places.

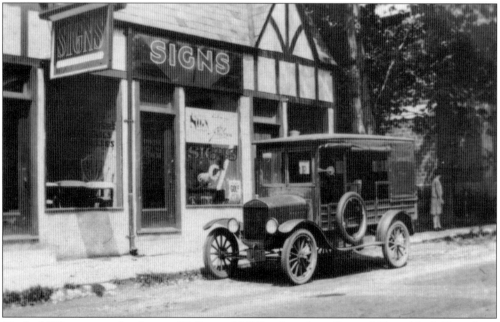

Gotfred Nilsson owned a shop at 97 Cutter Mill Road in the village of Great Neck Plaza from 1928, when this photograph was taken, until 1974. Nilsson painted signs for many businesses and real estate developments. He photographed his signs after they were placed, leaving a visual record for future reference. (Nilsson family photograph, courtesy of the Great Neck Library.)

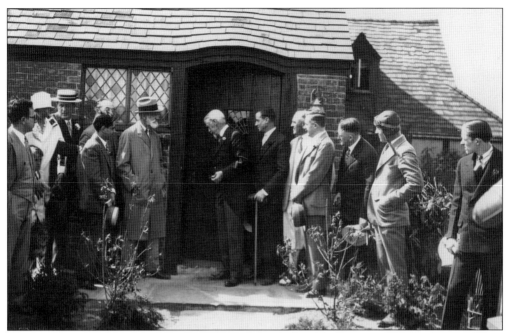

The developers of Russell Gardens, Frank Knighton and Ralph McPhee, actively advertised their development, even engaging W.C. Fields and D.W. Griffith, who were filming *Sally of the Sawdust* nearby. Seen in this 1926 publicity photograph showing the house at 219 Melbourne Road are, among others, Capt. Frederick Russell (with white beard), who sold the property to the developers, and Frank Knighton (fourth from right). (Courtesy of Russell Gardens.)

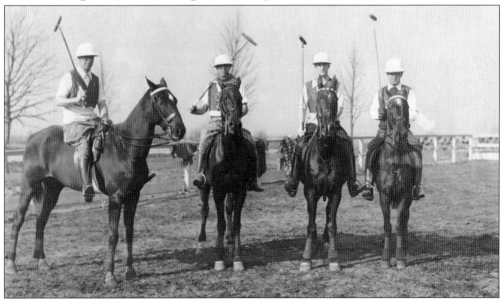

The land purchased from Captain Russell included a full-sized practice polo field bounded by Melbourne Road and Northern Boulevard, seen in this publicity photograph. The development also included stables. Riders could hire horses to ride on the bridle paths in Russell Gardens and University Gardens, through the unincorporated area on the south side of Northern Boulevard, and into the Lakeville area. (Courtesy of Russell Gardens.)

This 1914 advertising postcard features homes on Sheffield Road in the Villa development, in what is now the village of Thomaston. The Louise and Paul Shields Company announced that it was developing a tract of 50 acres at an elevation of 215 feet, with winding roads to eliminate city lots. Pairs of stone pillars still mark the entrances to the development.

The Great Neck Improvement Company purchased a cottage at the corner of Middle Neck Road and Susquehanna Avenue for a county club for its high-class development, Great Neck Hills. The remodeled cottage featured a bowling alley, and three tennis courts were added on an adjoining property. The Great Neck Hills and Great Neck Villa areas are now known as Thomaston.

Seven

THEY MADE THE NEWS

The coming of the railroad opened up Great Neck to settlement by men and women who needed to be within striking distance of Manhattan. Through the years, Great Neck has been home to many famous writers, musicians, actors, businessmen, and industrialists. As the grand estates were sold off, smaller holdings, with only a few acres but still containing grand houses, became the magnet that brought these folks to the peninsula.

Among those who found a place in Great Neck were members of the Broadway and literary circles. Great Neck became home to many theatrical figures and authors, as they settled not only on the larger estates in Kings Point, but also into the newly built communities of Kensington and Great Neck Estates. Guy Bolton, the well-known playwright of the 1920s and 1930s, was also famous for his Sunday open houses in Great Neck, and his writing partner, P.G. Wodehouse, moved to town to be near him. Bolton also collaborated with Oscar Hammerstein II, another local resident.

The parties were elaborate and frequent, the liquor flowed, the golf courses were right there, and the rich had their tennis courts. Others came from nearby Manhattan to party for the weekends, and Great Neck entertained such visitors as Enrico Caruso, Isadora Duncan, and Rudolph Valentino. Among the many other famous Great Neck residents of the past, not mentioned elsewhere in this book, are actors Basil Rathbone, Joan Crawford, and Jane Cowl, authors Margaret Wise Brown and Frederic Dannay, publisher Moses Annenberg, and industrialist August Heckscher.

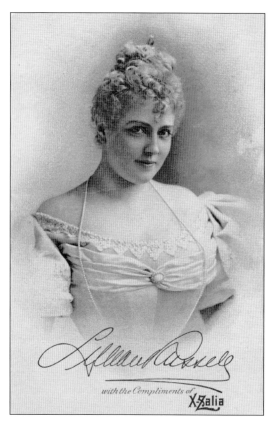

with the Compliments of
X-Ralia

Singer and actress Lillian Russell rented a 16-room cottage here for several years. In 1895, she donated $150 to single-handedly pay for the peninsula's Independence Day fireworks display, since the townsfolk were not willing to contribute to the campaign started by The League. She first drove an automobile in Great Neck, and was once picked up by the police for speeding—she had been going 18 miles per hour. (Courtesy of Alice Kasten.)

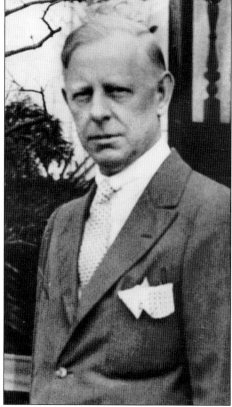

Jessie Livermore was described, in his day, as the most fabulous living American stock trader. He developed a set of rules about trading, and made and lost several fortunes on Wall Street. By following his own rules, he was worth $3 million after the Panic of 1907. He purchased his Kings Point estate for $250,000, and his wife installed a barbershop, a distillery, and a brewery in the basement.

George M. Cohan moved into a house bordering what is now Steppingstone Park in 1914. He wrote more than 300 songs, including "Over Here," which was written in that house, and "Forty Five Minutes from Broadway," which is reportedly about his Kings Point home. He was part of the Great Neck community, and his children attended the local public schools.

Cohan has been called the father of American musical comedy. The Village of Kings Point awarded landmark status to the Cohan house, but not to the outbuildings on the estate. After community outpourings of support and legal battles, a portion of the land was annexed to Steppingstone Park in 2001 by decree of the New York State Supreme Court.

Ring Lardner began his career writing sports columns, but moved on to writing short stories. He moved to Great Neck in 1919 to be closer to the theater, finally realizing his dream of having a show on Broadway. *June Moon* includes music and lyrics written by Lardner. He was a great friend of F. Scott Fitzgerald, who often attended parties at Lardner's house, which still stands on East Shore Road.

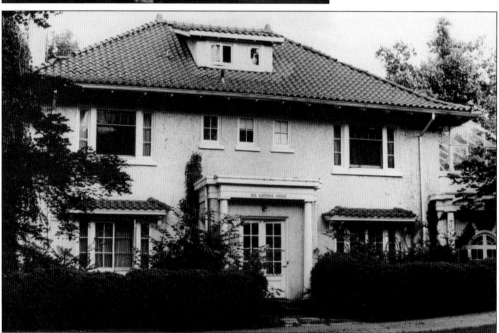

F. Scott Fitzgerald is probably the celebrity most linked to Great Neck, although he only lived here for about a year and a half. He rented this house on Gateway Drive in Great Neck Estates, moving here to be close to Broadway because he was hoping to become rich as a playwright. It was here that he got the inspiration for *The Great Gatsby*, and the fictional village of West Egg was inspired by Great Neck.

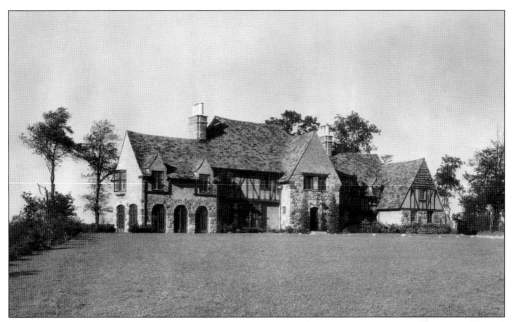

Oscar Hammerstein II rented a home at the corner of what are now Grace Avenue and Bond Street from 1921 to 1926, and then purchased this estate, which he called Sunny Knoll. Though he owned the house until 1943, he rented it out periodically, as his work often took him to Hollywood. Alan King owned the house in later years, and it was demolished after his death.

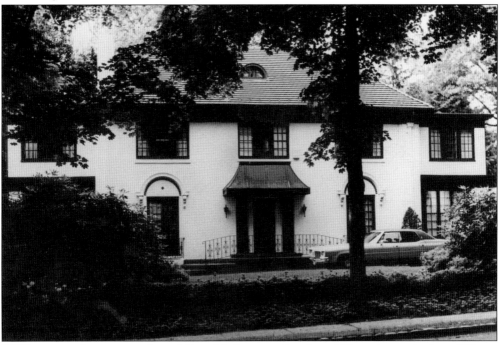

Ed Wynn was a longtime resident of Great Neck, occupying three different homes in three different villages. He lived in Great Neck Estates; in this home on Arleigh Road in Kensington; and then, in 1925, he purchased a $250,000 home on four acres in Kings Point, near Walter Chrysler's home. Wynn named the home Wyngate. His son Keenan Wynn grew up in Great Neck.

P.G. Wodehouse lived in Great Neck from 1918 to 1922. He came here to be near his writing partner, Guy Bolton, so he rented a guesthouse on Arrandale Avenue and golfed at the Sound View Golf Club. Wodehouse is well known for his Wooster and Jeeves stories, and one of his characters, Freddie Threepwood, presumably still lives on in Great Neck.

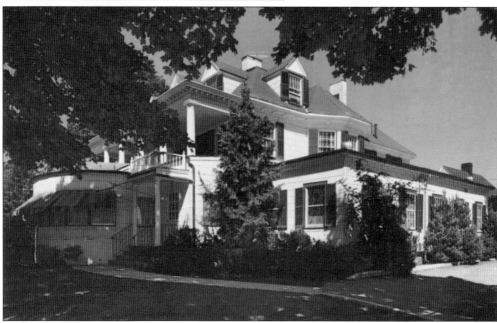

Maude Craig, an important restauranteur, set up business in an older building that had previously been a private home and another restaurant called the Hidden House. It quickly became a mecca for the local members of the television industry. Martha Raye, another Great Neck resident, held her wedding reception at Maude Craig's.

Sam Harris was the producing partner of George M. Cohan. Though they both worked separately as well, they collaborated on 18 musicals. Harris lived next to Cohan in a house that was later purchased by Olga Petrova on the site that is now Steppingstone Park. Harris married Cohan's second wife's sister, and he and Cohan were very close until they had a historic falling-out over labor contracts.

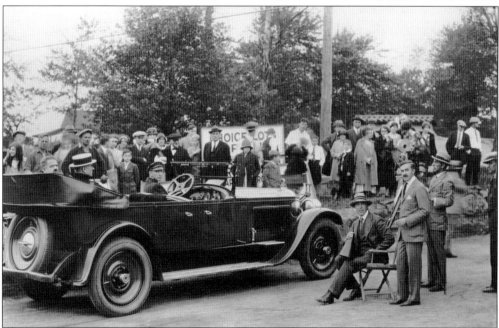

W.C. Fields, the comedian and star of the stage and screen, briefly rented a home on Dunster Road in Russell Gardens in 1928. In 1925, he had acted in the D.W. Griffith film *Sally of the Sawdust*, which was filmed here, and the developers of the village of Russell Gardens used his picture to help publicize its homes. He was also a member of the Sound View Golf Club.

Leslie Howard, perhaps best remembered for his role as Ashley Wilkes in *Gone With the Wind*, was a huge star in both plays and films. Howard was also possibly a spy; he died when British Overseas Airways Corporation Flight 777 was shot down by the Germans in 1943. There is speculation that the Germans were trying to prevent his meeting with Francisco Franco. He lived at 7 East Road in Kings Point in the mid-1920s.

Marilyn Miller lived on Nassau Drive in Kensington. The very popular actress, tap dancer, and singer worked with other Great Neck residents, including Eddie Cantor, Oscar Hammerstein II, and W.C. Fields. It is said that she was the inspiration for Marilyn Monroe's stage name.

Richard Tucker was an Orthodox Jewish cantor, a Great Neck family man, and one of the great tenors of his age. He moved to Great Neck in 1948 and was a regular commuter to and from the Metropolitan Opera. A member of the Stepping Stone Masonic Lodge and of Temple Israel, Tucker was a large presence in the life of Great Neck.

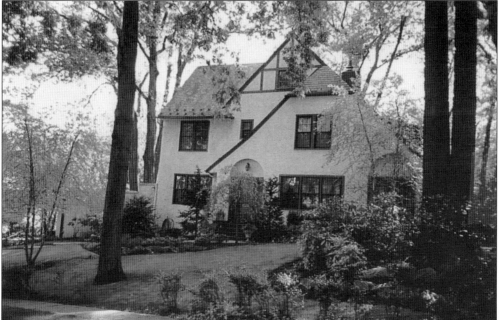

Groucho Marx moved to Thomaston in 1926 and lived in Great Neck for six years. His brother Chico lived in Great Neck Estates during the same time period. Many Long Island communities did not allow Jews to purchase homes at that time, but Great Neck was experiencing the first influx of the Jewish community, and Groucho lived in this home with his family before moving to Hollywood.

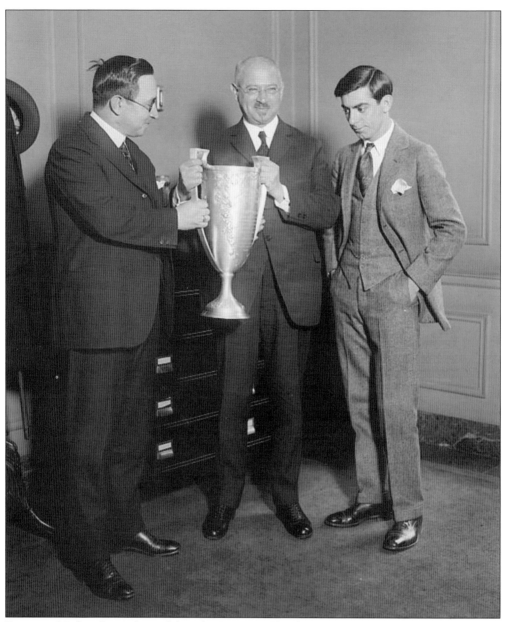

Financier Nathan Jonas (center) bought 50 acres of land in Great Neck in 1918 because Forest Hills had become too "citified." An avid golfer, he helped fund the tournaments at the Sound View Golf Club that paved the way for the Ryder Cup championship. He is seen here with Eddie Cantor (right), who looked upon him as a father figure. Cantor built a 17-room home on 10 acres in Lake Success, neighboring Jonas, in the late 1920s, although he only lived there briefly. It all was lost as a result of the stock market crash of 1929. While Cantor was well known for his performing, it is less well known that he was one of the writers of "Merrily We Roll Along," which became the Warner Bros. Merrie Melodies series cartoon theme, and helped found the March of Dimes.

Eight

WORLD WAR II

Great Neck responded with energy to the defense effort during World War II. Innumerable bond drives were held, committees were formed to prepare for emergencies, and a women's group discouraged hoarding. Plane spotters operated from the roofs of tall buildings, and preflight aviation training was offered at Great Neck High School. The community may have felt vulnerable because the Sperry Gyroscope plant, which employed up to 25,000 workers and manufactured a wide array of military products, was located in Lake Success. Barrage balloons flew 24 hours a day near the plant.

An article in the *Great Neck News* is headed "No More Bathing Beach," as the beach was being taken over for the United States Merchant Marine Academy on land purchased in 1942 from the elegant Walter Chrysler and Nicholas Schenck estates. The process was described as transforming a residential Shangri-la into a federal academy.

In 1945, the *Great Neck Record* reported that 90 percent of the Sperry staff was laid off in two days. Soon, the United Nations was inspecting the plant as a possible home for its security council. By 1950, more than two million sightseers had visited the converted war plant, according to the *New York Times*. The security council moved to New York City in 1952, and the arrival of UN workers and returning veterans brought another wave of housing demand. Sol Atlas began the building trend with the Schenck-Welwyn apartments, in the station area. Veterans' committees and UN workers negotiated a division of the rentals to assure returning military personnel a share of the apartments.

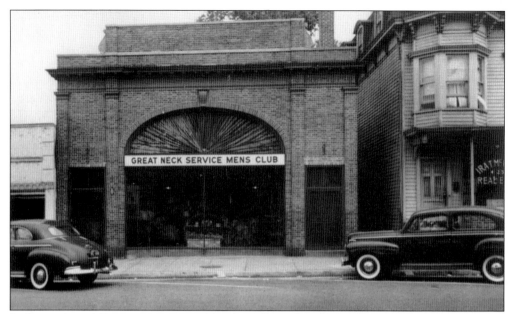

In September 1942, it was announced by the Office of Civilian Protection that a service club for men in uniform would be opened in the former Hudson showroom on Station Plaza North. Representatives of the Merchant Martine Academy and the USO participated in the planning. Hostesses, trained by the Red Cross, maintained a canteen, and auxiliary policewomen used the club regularly for drill. (Courtesy of Helene Herzig.)

An honor roll with the names of more than 1,400 men and women who served in the armed forces during World War II was erected at the railroad station. Dedication ceremonies, organized by the American Legion, were held on September 18, 1943. The sign was financed by more than 500 individual contributions. The United States Maritime School drill team gave an exhibition. (Courtesy of Helene Herzig.)

Great Neck prepared actively for the possibility of an enemy attack. The community's first ambulance is seen here parked in front of the Vigilant Fire Company Station on North Station Plaza. The Vigilants, one of three fire companies on the peninsula, later moved to Cutter Mill Road. (Courtesy of Helene Herzig.)

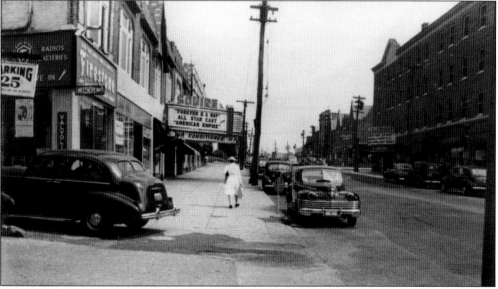

At the time of this photograph, *Forever and a Day* and *American Empire* are the films playing at the air-conditioned Squire Theater (left). At the Playhouse Theater, across Middle Neck Road, the film is *Lady of Burlesque*, staring Barbara Stanwyck and Michael O'Shea. This photograph and the previous three were taken in 1945 to be mailed to Philip Herzig, a young soldier from the village of Kensington serving in Germany. (Courtesy of Helene Herzig.)

The roof of the Colony Hotel, located on the corner of Bond Street and Grace Avenue, was used for plane spotting during World War II. A field hospital with 30 beds was established by the Great Neck Defense Council in the adjoining Westminster Apartment Building, just visible to the right. Plane spotters also used the roof of the Towers Apartments in Thomaston.

The Wing Scout program began in 1941 for senior Girl Scouts who wanted to learn about aviation in order to serve their country. Other photographs show that the uniforms were bright green. This black-and-white photograph was donated to the Great Neck Library by Barbara Freedman Wolfson. (Joan Faigle photograph, courtesy of Great Neck Library.)

The Mariner's Memorial Chapel overlooks Long Island Sound on the Kings Point Merchant Marine Academy campus. On the eve of World War II, training schools for the Merchant Marines were considered inadequate. In 1942, the Chrysler and Schenck estates in Kings Point were chosen as the new location to train cadets. Today, the Merchant Marine Academy is one of the five federal service academies.

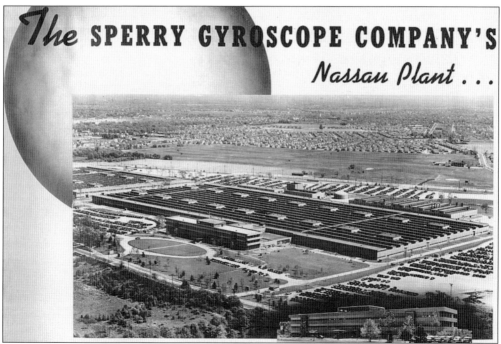

The Sperry Gyroscope Company plant, built by the federal government, was located in Lake Success beginning in 1943, occupying more than 147 acres bordered by Lakeville Road, New Hyde Park Road, and Marcus Avenue. During World War II, it employed up to 25,000 workers, who manufactured a wide array of military products, such as bombsights, gun turrets, and radar systems. (Courtesy of the Cradle of Aviation Museum.)

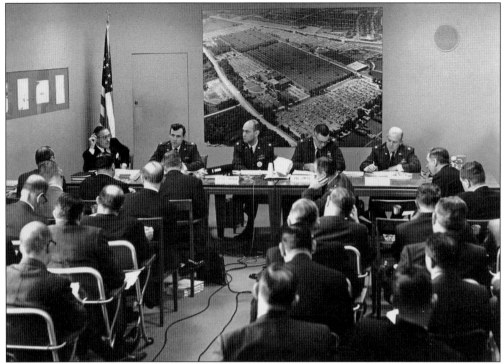

A background photograph of the Sperry Gyroscope plant in Lake Success overlooks what appears to be a very important meeting with military officials at the plant. One report noted that the Village of Lake Success received $20,000, half of its taxes, from the Sperry Company. (Courtesy of the Cradle of Aviation Museum.)

The cars of United Nations delegates are parked in the entry drive of the Sperry Gyroscope administration building in Lake Success on April 5, 1945, while the delegates inspect the building as a possible interim site for the UN Security Council. Some 7,000 Sperry workers continued to work there. (Courtesy of the Howard Kroplick collection.)

The former Sperry Gyroscope plant in Lake Success was the temporary home of the UN Security Council from May 1946 until 1952. The various divisions of the United Nations were popular tourist attractions, and the *New York Times* printed directions to Lake Success. UN representatives from more than 50 countries sometimes expressed concern about the long hours and the difficult commute. Sperry returned to the building when the UN left.

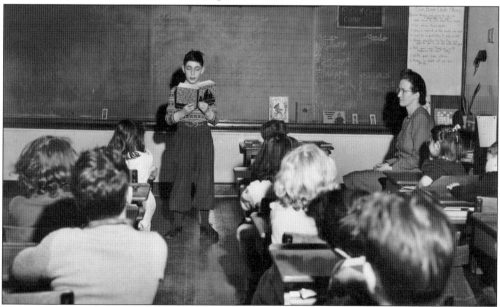

The UN Security Council brought many representatives of other countries and their families to the community. In this 1948 photograph, Philippe Pressel takes his turn reading for an English class. The original photograph caption reads, "The youngsters are generally quick at picking up languages, so the teachers in the Great Neck school have little trouble with their new pupils."

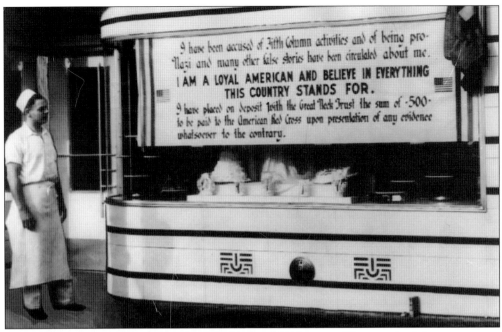

I have been accused of Fifth Column activities and of being pro-Nazi and many other false stories have been circulated about me. **I AM A LOYAL AMERICAN AND BELIEVE IN EVERYTHING THIS COUNTRY STANDS FOR.** I have placed on deposit with the Great Neck Trust the sum of $500 to be paid to the American Red Cross upon presentation of any evidence whatsoever to the contrary.

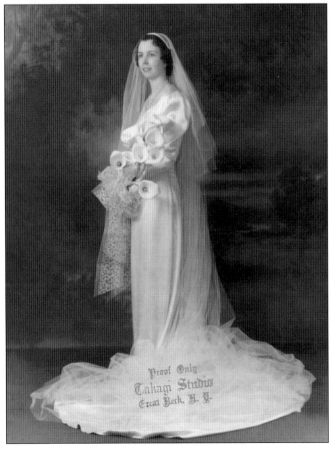

Proof Only
Takagi Studio
Great Neck, N. Y.

The oversized sign seen in the window of Louis Uhlemann's bakery shop at 56 Middle Neck Road on June 13, 1940—a year and a half before the United States entered World War II—is clearly a reaction to some community members' comments about possible secret sympathy with the Nazis that a man with a name of German origin might have.

Like many Great Neck residents, Mary Coyle of Saddle Rock chose the Takagi Studio for her wedding portrait. On December 12, 1941, five days after the attack on Pearl Harbor, Vincent Takagi, who had photographed residents for 16 years, was forbidden to take photographs by a war ruling denying aliens the right to use cameras. One week later, Takagi advertised that he was again permitted to conduct business.

Nine

COMMUNITY INVOLVEMENT

From its early days, Great Neck has been noted as a place in which local residents get involved. In the 1700s and 1800s, involvement meant getting the schools organized, and in the 1900s, civic duty turned toward the formation of villages and various community service groups. The volunteer fire forces became an important part of the community, and many other residents found their focus in their religious associations. The volunteers of the peninsula have made the various organizations what they are today. The institutions that Great Neck takes for granted all arose from the spirit of volunteerism and a sense of what was needed to better the community.

Some of the organizations founded this way had wealthy backers; the names of Louise Eldridge and Francoise Barstow are seen time and time again as the founding backbones of the best of Great Neck. Together, they were responsible for the beginnings or the endowment of the library, the park district, a legitimate theater, the Woman's Club, and the Girl Scouts. But they could not have achieved this without the participation of the people of the peninsula, who got involved, raised money, and became the heart of these various organizations.

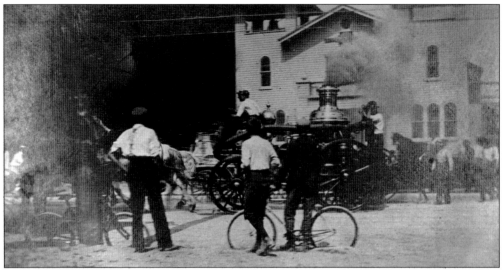

The Alert Fire Company, founded in 1901, owes its initial funding to such local luminaries as Brokaw, Meyer, Grace, and Eldridge. At the beginning, it did not even own horses. Speedy arrival at fires was ensured by paying the first person who hooked up his team of horses when the alarms—sledgehammers hitting railroad ties—sounded. Local resident Walter Chrysler donated the first fire truck.

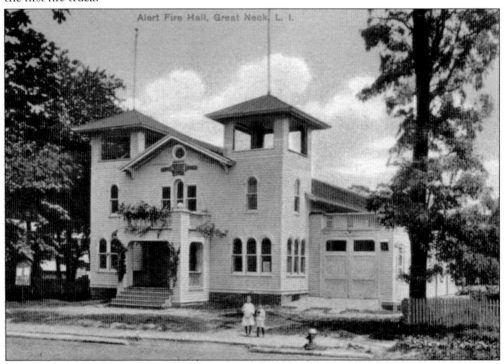

The original Alert firehouse was built in 1904, with William K. Vanderbilt II contributing $1,000 toward the construction. In the early days, firehouses were social gathering places as well, and the Alerts maintained a dance hall to help pay their expenses. The dance hall was lost when the firehouse was remodeled in the 1920s. The current building was erected in the 1980s, and the old one was demolished.

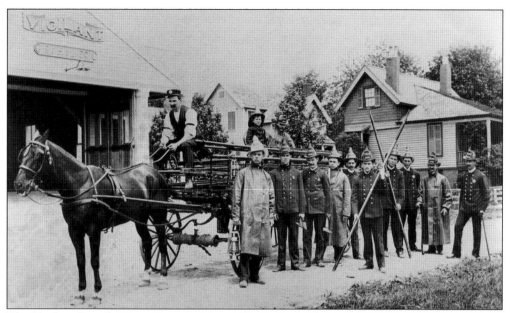

The Vigilant Fire Company was incorporated in 1904, as there was no protection at the south end of town. Its guardian angel was also William K. Vanderbilt II, who helped fund the first equipment and sometimes went out on fire calls with the company. The firehouse was located where Riverside Funeral Home now stands, at North Station Plaza, and the company used the horses belonging to Robertson's bakery, down the block.

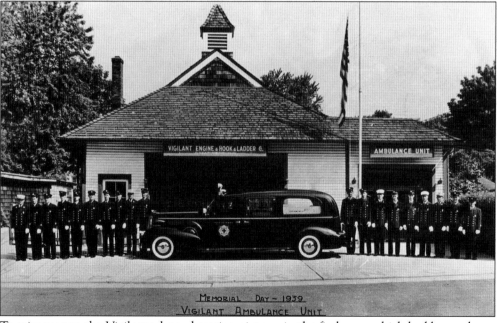

To raise money, the Vigilants showed motion pictures in the firehouse, which had been a barn. They also used some of the actors who had settled in Great Neck for fundraising shows, making their firehouse another local social gathering place. Celebrities not only helped fundraise, they also took an active part. Well-known talk show host Virginia Graham even drove the ambulance during World War II.

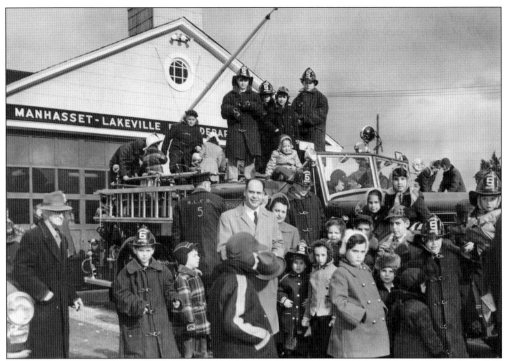

The Manhasset-Lakeville Fire Department operates five companies, two of which are presently located in Great Neck. Company No. 3, located on Prospect Street in Thomaston, was founded in 1912, with familiar Great Neck names such as Schenck, Roe, and Robinson as original members. The first truck was acquired in 1917.

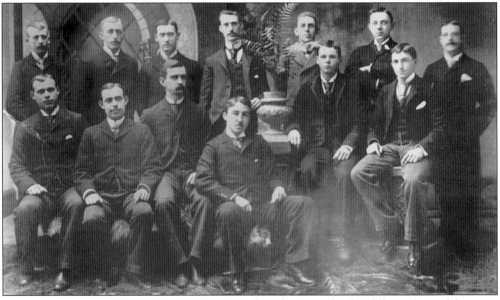

The League was a social club for young men located on the west side of Middle Neck Road, between Brokaw Lane and Baker Hill Road. It housed a bowling alley and a pool table. The building itself was owned by a Miss Post, who was one of the benefactors of the library. In 1903, the building was given to All Saints Church, which rented it to The League for its use.

The Woman's Club got its start in the 1910s, and the land and the present building were donated in the 1930s by Francoise Duclos Barstow, who made her home in what is now the museum of the Merchant Marine Academy. During both world wars, the women knitted apparel for the military, and have more recently been involved in retyping stories into braille and giving courses in nutrition and first aid.

Francoise Barstow also donated the building known as Girl Scout House, at 43 Berkshire Road. Generations of girls attended troop meetings, had sleepovers, and learned social skills at the community center. The building was razed in the 1980s; today, five private homes stand on the land. Barstow also helped to fund Camp Francoise Barstow, a Girl Scout camp located in Miller Place, now called Cordwood Landing County Park.

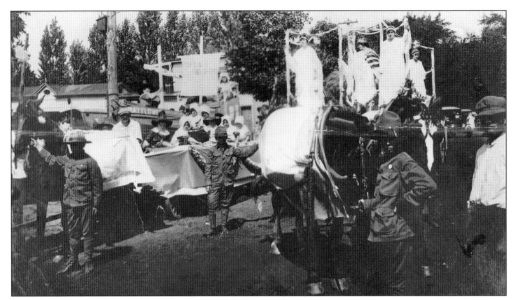

Boy Scout Troop 10 got its start in 1915 when a group of boys appeared at the Susquehanna Avenue home of Howard Covey, a local teacher. They asked him to be their Scoutmaster, and the troop has been in existence ever since. The first meetings were held above Covey's garage. The boys are seen here in a Thanksgiving Day parade, complete with a horse-drawn float, in 1918. (Courtesy of Howard Bauman.)

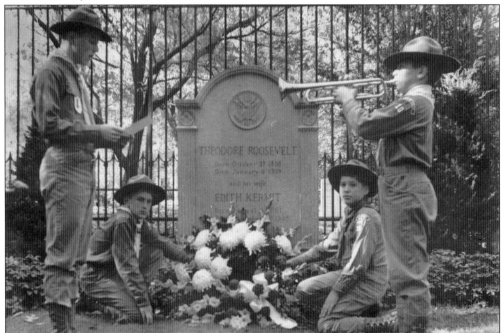

Troop 10 was officially chartered by former president Theodore Roosevelt in 1917; it was one of his first acts in his position as the commissioner of the Nassau County Boy Scouts. The troop, nicknamed the Rough Riders, still visits President Roosevelt's grave annually. It is one of the oldest Boy Scout troops in the United States; more than 2,000 boys have worn the Troop 10 numeral patch. (Courtesy of Howard Bauman.)

Troop 10 participates in its share of conservation and environmental projects and food drives, as well as the other activities of Scouting. In 1965, in an unusual turn of events, the troop was flown from New York to Hartford, Connecticut, by TWA. First Lady Lady Bird Johnson was present on the plane, and chatted with the troop. Upon landing, the boys hiked off for their overnight. (Courtesy of Howard Bauman.)

The ladies of the Nokomis Chapter of the Eastern Star pose for a photograph in 1940, most likely at the Masonic temple, at Middle Neck Road and Maple Drive. The Paumanok Masonic Lodge, which originated in Great Neck, now meets in Port Washington. Great Neck was also home to the Stepping Stone Masonic Lodge.

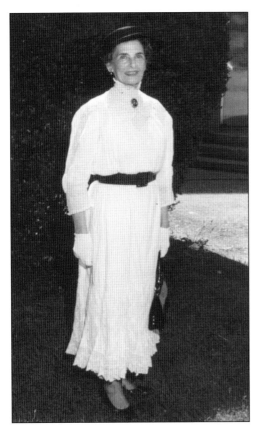

The Great Neck Health League was founded in 1913 by a group including Mrs. Silas McBee, Louise Eldridge, Elise Gignoux, and a daughter-in-law of Cord Meyer. Its goal was to help care for the thousands of immigrants who had recently settled here, many of whom had arrived to serve the wealthy on their estates. Since the nearest hospital was in Mineola, a professional nurse was hired, who made home visits on foot on nice days and used Louise Eldridge's sleigh on snowy days. After World War I, the Health League added a preschool nursery for the children of working mothers. Eventually, the name of the organization was changed to the Great Neck Visiting Nurse Association. Here, Josephine November (left) and Helene Herzig (below) are seen in period nursing costumes from 1913 and 1928, respectively.

The Great Neck Players performed in the old Union Chapel. An outgrowth of the Woman's Club, they formed a separate organization so they could accept men. Their first production, in 1929, was *The Romantic Age* by A.A. Milne. In 1938, Louise Eldridge added a wing, had the floor sloped, installed new seats, and added a workshop. The building also housed a professional summer stock group in 1938.

The nondenominational Union Chapel was the first religious institution in Great Neck, and All Saints Episcopal Church (pictured) was the first grand house of worship. The church was built in 1886 on land donated by two wealthy farming families, the Messengers and the Gignoux, and designed by the architects who planned St. Patrick's Cathedral. Inside are four Tiffany windows; outside, in the cemetery, lie members of many of Great Neck's founding families.

Great Neck Players

SEASON 1937-1938

•

•

CHAPEL PLAYHOUSE

340 MIDDLE NECK ROAD

GREAT NECK, L. I.

All Saints Episcopal Church, House and Rectory, Great Neck, N. Y.

In 1872, Joseph Spinney, a commission merchant, donated the funds to build a Methodist church on what is now Northern Boulevard. The cost of the beautiful church topped $21,000. Unusual for its day, the Woman's Foreign Ministry Society was established there in 1888, and it sponsored the education of a girl in China that same year. The original wooden church burned in 1948 and was rebuilt of brick.

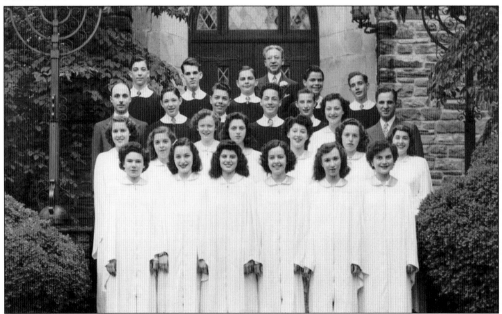

Today, Great Neck is home to approximately 20 synagogues. Temple Beth-El was the first, founded in 1928. Avram Wolf, the tailor of former New York City mayor and Great Neck resident W.R. Grace, was one of the principal founders of the temple and of the Jewish community in Great Neck. Until the temple was constructed, the congregation worshipped at the Community Church on Bond Street.

Ten

RECREATION AND CELEBRATIONS

In the 1800s and early 1900s, the beauty of the peninsula attracted vacationers to its beaches and small resort hotels. Emily Childs wrote of the steamboat trip from Manhattan, "When I looked across the Sound and saw a green point of land running out into very blue water, I thought I had never seen so lovely a spot as Great Neck." To the south, stagecoaches brought guests to the resort hotels near the beautiful kettle lake in Lake Success, which offered boating, fishing, and swimming. Several of the big estates had polo fields, racetracks, and riding stables. The glacial topography of the area is ideal for golf courses. A 1929 article in the *New York Times* notes that Great Neck has a greater concentration of golf clubs than any other area of the country.

On holidays, bands, firemen, and veterans marched the length of Middle Neck Road. Patriotic holidays were celebrated on the village green. Around 1910, movies were shown in an open-air theater on Middle Neck Road, and later at the Mayfair Theatre, on Station Plaza North. For many years, two movie houses, the Squire and the Playhouse, operated on opposite sides of Middle Neck Road. Local theater groups, which performed at the Chapel Theatre, and professional Broadway tryouts, held at the Playhouse Theatre, offered high-quality entertainment.

In 1916, Louise and Roswell Eldridge filed petitions to establish the Great Neck Park District, which their village, Saddle Rock, never joined. The park district has flourished, and residents of many areas of Great Neck enjoy neighborhood parks, a pool, an ice rink and tennis complex, and a magnificent waterfront park that hosts musical entertainment in the summer.

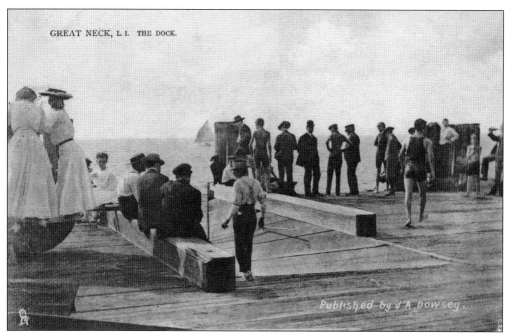

Published by J A Dowsey.

Great Neck residents and visitors to the peninsula's hotels were frequently attracted to the waterfront, with its opportunities for swimming and boating. J.A. Dowsey published many postcard views of northern Great Neck in the early 1900s. This photograph was likely taken at a dock in Kings Point. The card was mailed in 1911.

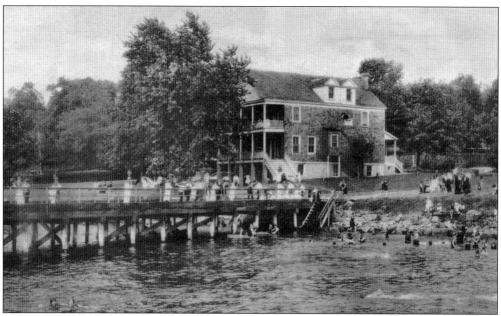

Louise Eldridge, one of the founders of the Great Neck Park District in 1916, arranged to convert Hayden's coal yard into a public beach. Purchased for $40,000, the public bathing beach was the first park in the district. It had a large pavilion and a dock. Bathers are seen here in the water, an activity no longer permitted in the area because of water pollution.

114

The public bathing beach, which was less than two acres, became increasingly congested, and its nearby neighbor, Walter Chrysler, objected to the noise. In 1927, he offered an alternative location, the former Olga Petrova property. It was rejected by the park district. In 1942, when the Merchant Marine Academy moved to Kings Point, the Petrova property was finally developed, as Steppingstone Park.

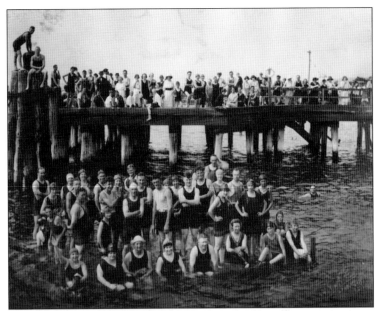

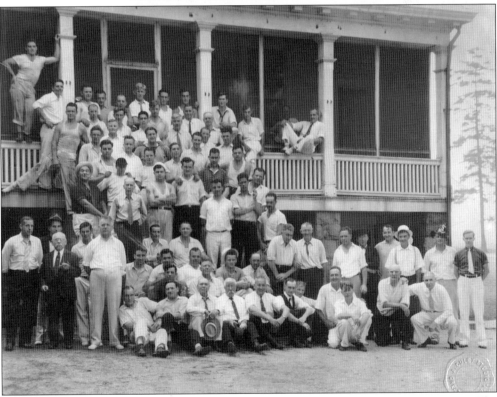

Besides protecting the peninsula, the local fire companies also served as social organizations. The Alert Fire Company enjoyed annual picnics at the public bathing beach. Some of the firemen in this photograph, taken by Great Neck photographer Alexander Culet, have been identified as, in no particular order, John Britten, Frank Gilliar, Joe Harnell, Herb Ninesling, Herbert H. Ninesling, Will Ninesling, Fred Reed, Tim Reed, and Andrew Weiss.

Great Neck was a popular summer resort in the early 1900s. In 1913, a guest at Shore Cottage, a resort hotel in Kings Point, drew lines on this postcard indicating his room. Nearby Oriental Grove, which also had rooms for guests, was leased to an excursion company that transported New York City residents by barge and steamer to dine or picnic. A dancing platform and a bandstand were also available.

Brookdale Hotel was at the corner of Middle Neck Road and Station Plaza South. In 1911, when this photograph was taken, the area near the railroad station was mostly farmland on the verge of being converted to housing developments. Peter Kane and Hattie Shreeve Kane, the hotel proprietors, are fifth and sixth from the left.

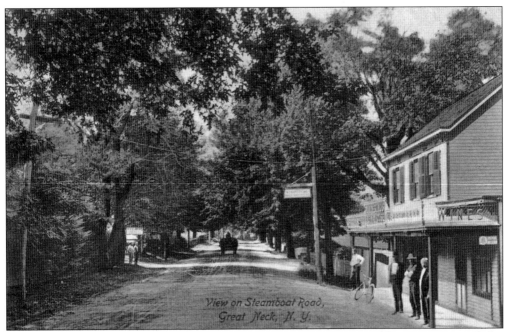

The sign on this building on Steamboat Road reads, "W. Ninesling's Half Way House," and also advertises "Wines." William Ninesling's hotel is listed in the earliest telephone book available, from 1913. Dr. Alexander Allen remembered that Ninesling's was one of many saloons. The hardworking employees of the many estates often went there to have a beer.

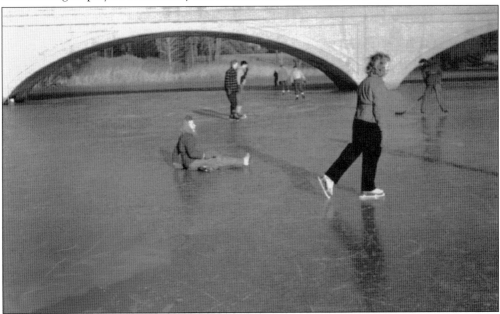

Skaters take advantage of the frozen millpond near the Bayview Avenue Bridge. The Great Neck Peninsula has many streams and ponds, which are ideal for ice-skating when the weather cooperates. More recently, Parkwood ice rink, managed by the park district, has been available for skaters. In 2002, Great Neck figure skater Sarah Hughes won an Olympic gold medal. (Charles Quatela photograph, courtesy of Great Neck Library.)

OPEN AIR ARTIFICIAL ICE RINK
3 Sessions Daily—10.30 to 12.30—2.30 to 5.30—8.30 to 11 p.m.
GREAT NECK ICE SKATING RINK, INC.
GREAT NECK, NEW YORK

Pavilion and Lunch Counter

This advertising postcard for the Open Air Artificial Ice Rink, at 100 Cutter Mill Road, is postmarked 1941. The facility hosted other activities when it was not being used as a skating rink, including the North Shore Antiques Fair and boxing matches. The Great Neck Park District opened Parkwood ice rink on Arrandale Avenue in 1964.

In his book about the Baker farm, Mills P. Baker writes that in his last two years of high school, they had sleigh rides, usually on Friday nights, and that Solomon Harris was the driver of the sleigh. In 1937, Harris was photographed driving the sleigh for Baker's sister Anna and her children. Baker dedicated his book to Solomon Harris. (Baker family photograph, courtesy of Great Neck Library.)

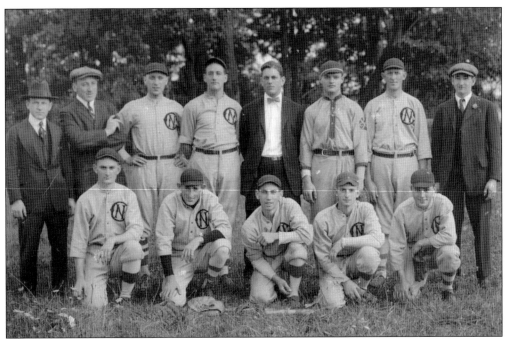

Baseball players on the Great Neck Athletic Club team pose for this image, taken by Great Neck photographer Alexander Culet around 1915. Some of the players, identified by Dorothy Weiss Carpenter, are Matthew Grassberger (first row, second from left) and Andrew Weiss, Gene Bishop, and Tim Reed (second row, fourth, seventh, and eighth, respectively). The club also sponsored football and basketball teams.

In 1899, the first horse show was held at Gracefield Farm, the summer home of W.R. Grace. This photograph of an unidentified woman on horseback was taken at the 1928 Great Neck Horse Show. The W.R. Grace estate, the Brokaw estate, and Capt. Frederick Russell's property all had polo fields. William Gould Brokaw offered free admission to the public once a year at his polo field.

Parades were frequent on the peninsula. This professional news service photograph was taken on Labor Day, September 6, 1915. The *New York Times* reported that flag-raising ceremonies began at 5:20 a.m. That morning, the firemen paraded down Middle Neck Road past the Masonic temple, the large white building on the southeast corner of Maple Street. Members of the National Guard Band are on the left.

The Labor Day speech in 1915 was given to a large crowd at the railroad station by Adm. Aaron Ward, US Navy Ret., a resident of Roslyn. He spoke in favor of a larger army and navy, and against peace at any price. The celebration also included prizes for the best decorated car. Lillius Grace, the wife of W.R. Grace, received first prize, followed by Henry F. Guggenheim. (Courtesy of the Library of Congress.)

For this postcard, postmarked 1911, J.A. Dowsey photographed two well-dressed young men relaxing in a wooded area known as the Great Swamp. The swamp, once used as a dump, was converted into Kings Point Park in 1931 by workers employed by the Great Neck Emergency Employment Committee. The 175-acre park, which retains some of its original forest, is leased to the park district by the Village of Kings Point.

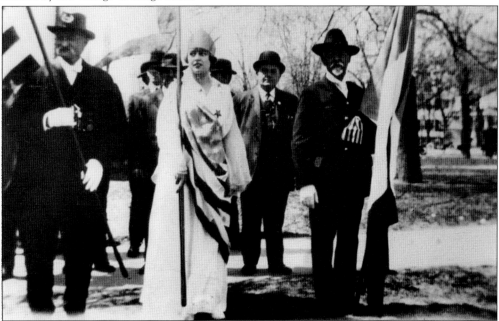

In 1918, Great Neck Civil War veterans attended a Liberty Bond rally near the white frame schoolhouse at the intersection of Arrandale Avenue and Middle Neck Road. The three people in front are, from left to right, Fred Faigle, Florence Lane, and Thomas Thurston. In 1861, a Civil War regiment, the Jackson Guards, had trained from a large tent camp established near Elm Point. (Thurston family photograph, courtesy of Great Neck Library.)

William Gould Brokaw's grand estate extended from the Saddle Rock millpond to this spot on Middle Neck Road. Louise Eldridge requested permission to stage a welcome home celebration for World War I soldiers on this site, and then arranged to purchase five acres bordering Middle Neck Road from Brokaw for a park, which became the village green. Many residents participated in the funding, with schoolchildren contributing $24.38 just in pennies.

The Great Neck Liberty Band played at the dedication of the bandstand on the village green. The bandstand was built in 1928 in memory of Louise Eldridge's husband, Roswell, who died in 1927. A noted landscape architect, Beatrix Ferrand, provided the landscape plan for the park as well as for the Eldridge estate. (Thurston family photograph, courtesy of the Great Neck Library.)

Movies came to town around 1910. Some films were shown outdoors under a canopy set up in a field. The audience sang along with a piano player with the words projected on slides. Kids climbed trees to watch. The Airdome, seen here, was an outdoor movie theater on Middle Neck Road, opposite North Road. It had a dirt floor, and films were shown after sunset and canceled in the event of rain.

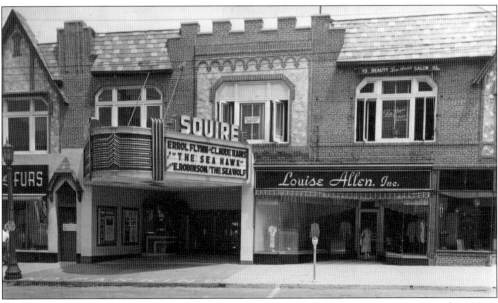

The Squire Theater opened officially on January 15, 1941, with a seating capacity of 1,200. It was directly opposite the newly remodeled Playhouse Theater on Middle Neck Road. The film advertised on the Squire marquee in this postcard opened in 1941. The entire proceeds of the opening show were donated to the British War Relief Society.

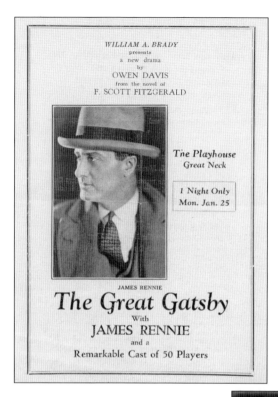

WILLIAM A. BRADY
presents
a new drama
by
OWEN DAVIS
from the novel of
F. SCOTT FITZGERALD

The Playhouse
Great Neck

1 Night Only
Mon. Jan. 25

JAMES RENNIE
The Great Gatsby
With
JAMES RENNIE
and a
Remarkable Cast of 50 Players

The Great Neck Playhouse, built in 1922, opened in 1925 as a full-scale, legitimate theater hosting Broadway tryouts. A total of 29 shows opened there, including *The Great Gatsby*, based on the novel by F. Scott Fitzgerald, who lived in Great Neck from 1922 to 1924. In the 1930s, United Artists bought the building for a movie house. In 1982, it was restored as a theater, but it closed the next year.

Sally James Farnham's first sculpting commission was for the Great Neck Steeplechase Cup in 1904, which was won by W.R. Grace. The self-taught sculptor, who lived on Kings Point Road and had a studio in Great Neck, went on to create larger works like the statue of Simon Bolivar that is now in New York's Central Park. Farnham is buried in the All Saints churchyard. The bust she holds in this photograph is of Herbert Hoover. (Courtesy of the Library of Congress.)

In the 1920s, Coyle family members climbed the boulder known as Saddle Rock near their home. An 1874 *Popular Science Monthly* describes a rock resembling a saddle near David Allen's farm on Little Neck Bay. In 1927, the magazine reported that the water had retreated, revealing a bed of oysters that were large and possessed the most delicate flavor. Saddle Rock oysters were famous for many years.

The tall house seen here in 1915 behind Lulu Allen Smith had a long history. It was moved to this location on Susquehanna Avenue from Northern Boulevard, where it had been owned by Benjamin Wood, the owner of the *New York Daily News* and a member of the New York State Senate and the US Congress. The postal service suspended Wood's newspaper in 1861 because of its sympathy with the Confederacy. (Smith family photograph, courtesy of Great Neck Library.)

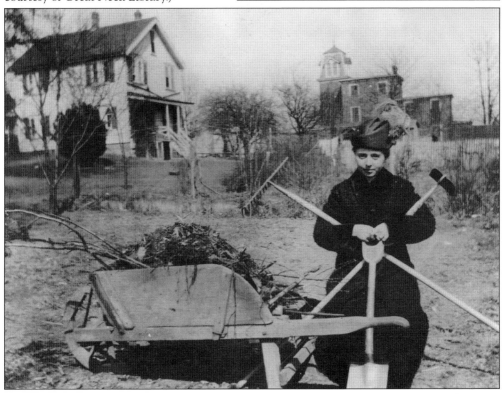

BIBLIOGRAPHY

Baker, Mills P. *Breezy Hill: The Baker Hill Farm*. Great Neck, NY: self-published, 1993.

Binder, Jack. *Wilderness to Lake Success*. Lake Success, NY: Village of Lake Success, 2004.

Coe, Corinne, ed. *Village of Thomaston, Great Neck, NY*. Thomaston, NY: Incorporated Village of Thomaston, 1976.

Cutter, Bloodgood. *The Long Island Farmer's Poems*. New York: Timbals & Sons, 1886.

Ellard, Robert A. *Old Great Neck*. Great Neck, NY: unpublished manuscript, 1963.

Match, Richard. *Lucky Seven Union Free School District Number 7*. Great Neck, NY: Great Neck Public Schools, 1964.

Mitchell, C. Bradford. *We'll Deliver: Early History of the United States Merchant Marine Academy, 1938–1956*. Kings Point, NY: United States Merchant Marine Academy Alumni Association, 1977.

National Cyclopedia of American Biography. New York: James T. White & Company, 1897–1984.

Records of the Towns of North and South Hempstead Long Island. Jamaica, NY: Long Island Farmer Press, 1896.

Relkin, Dolly, ed. *The Great Neck Library 1880–1989*. Great Neck, NY: Great Neck Library, 1989.

Silver, Nathan. *The Village of Great Neck: People remember it the way it was*. Great Neck, NY: Incorporated Village of Great Neck, 1996.

Spear, Devah and Gil Spear, eds. *The Book of Great Neck*. Great Neck, NY: self-published, 1936.

This is Great Neck. Great Neck, NY: The League of Women Voters of Great Neck, 1975.

Zarin, Renee and Karen Weisberg, eds. *In Celebration, the first 100 years: the Great Neck Library, 1889–1989*. Great Neck, NY: Great Neck Library, 1990.

ABOUT THE GREAT NECK HISTORICAL SOCIETY

The Great Neck Historical Society is a nonprofit organization dedicated to collecting, preserving, and presenting the history and heritage of the Great Neck peninsula. Frequent historically informative programs are presented throughout the year, and the group's tours of the peninsula are very popular.

The society has embarked on a very successful recognition program, which honors homes and other buildings of historic interest with plaques and certificates. For further information about the Great Neck Historical Society, please visit its website, www.greatneckhistorical.org.

DISCOVER THOUSANDS OF LOCAL HISTORY BOOKS
FEATURING MILLIONS OF VINTAGE IMAGES

Arcadia Publishing, the leading local history publisher in the United States, is committed to making history accessible and meaningful through publishing books that celebrate and preserve the heritage of America's people and places.

Find more books like this at
www.arcadiapublishing.com

Search for your hometown history, your old stomping grounds, and even your favorite sports team.

Consistent with our mission to preserve history on a local level, this book was printed in South Carolina on American-made paper and manufactured entirely in the United States. Products carrying the accredited Forest Stewardship Council (FSC) label are printed on 100 percent FSC-certified paper.

MADE IN THE USA